**Famous
Artists School**

How to Draw
and Paint Portraits

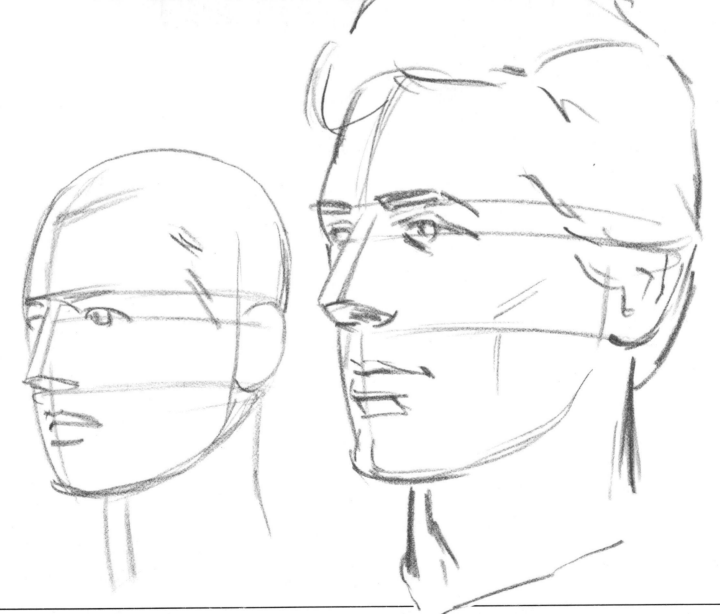

Albert Dorne
In founding the Famous Artists School Albert Dorne turned a dream into a reality. Having been one of the top illustrators in the country for years, Dorne had generously helped and advised many aspiring artists. Founding the School and rounding up the finest art faculty in America enabled him to help many hundreds more.

Ben Stahl
From the time he won an art school scholarship while in his teens, Ben Stahl has impressed both the public and his fellow artists with the versatility and power of his drawings and paintings. With his generosity of spirit, he has always been glad to use part of his time teaching and inspiring others.

Al Parker
Respected and admired as a pacemaker in his profession, Al Parker's many awards include the Society of Illustrators' "Hall of Fame" Award, one of the most coveted in the profession.

Among his many superb illustrations are those in his well-known series of "Mother and Daughter" paintings.

Jon Whitcomb
As a glamorizer of beautiful women, Jon Whitcomb is unequaled. Movie stars and society women yearn to have their portraits painted by him. Having had a long and phenomenally successful career in magazine and advertising illustration, Jon has also specialized in private portraits—and is very much in demand.

Norman Rockwell
The drawings and paintings of Norman Rockwell have probably been seen and loved by more people than those of any other artist. He achieved his eminent position because of his great talent and unceasing study. His distinctive calendars, posters, book illustrations and magazine art are world-famous.

Learn to DRAW AND PAINT PORTRAITS with the easy-to-follow methods of these FAMOUS ARTISTS!

The Famous Artists School series of books pools the rich talents and knowledge of a group of the most celebrated and successful artists in America. The group includes such artists as Norman Rockwell, Albert Dorne, Ben Stahl, Harold Von Schmidt, and Dong Kingman. The Famous Artists whose work and methods are demonstrated in this volume are shown at left.

The purpose of these books is to teach art to people like you—people who like to draw and paint, and who want to develop their talent and experience with exciting and rewarding results.

Contributing Editor
Charles M. Daugherty

PUBLISHER'S NOTE
This new series of art instruction books was conceived as an introduction to the rich and detailed materials available in Famous Artists School Courses. These books, with their unique features, could not have been produced without the invaluable contribution of the General Editor, Howell Dodd. The Contributing Editors join me in expressing our deep appreciation for his imagination, his unflagging energy, and his dedication to this project.

Robert E. Livesey, *Publisher*

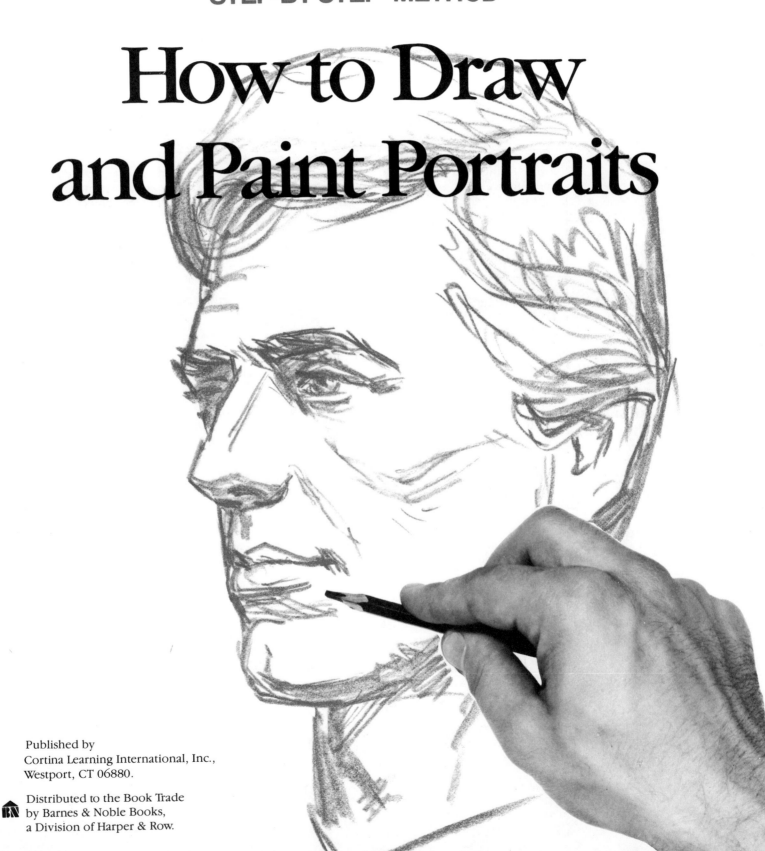

 Famous Artists School

STEP-BY-STEP METHOD

How to Draw and Paint Portraits

Published by
Cortina Learning International, Inc.,
Westport, CT 06880.

Distributed to the Book Trade
by Barnes & Noble Books,
a Division of Harper & Row.

How to Draw and Paint Portraits
Table of Contents

Printed in the United States of America
9 8 7 6 5 4 3 2 1

ISBN 0-8327-0903-4 ISBN 0-06-464071-X

Designed by Howard Munce

Composition by Typesetting at Wilton, Inc.

Your Practice Projects...*how they teach you*

Instructor Overlay

Your Practice Project

Instruction Sections

Instructor Overlays for Practice Projects

Tracing Paper Sheets

Free Art Lesson

The Practice Projects accompanying each new subject give you the opportunity to put into immediate practice what you have just learned.

You can draw directly on the Project pages, using ordinary writing pencils, or take a sheet of tracing paper from the back of the book and place it over the basic outline printed in the Project and make experimental sketches. Also, you can trace the printed outline and transfer it onto any other appropriate paper. (The transfer method is explained on page 80.)

Instructor Demonstrations for the Projects are located in the last section of the book. They are printed on tracing paper overlays. You can remove them and place them either over your work or over white paper so you can study the corrections and suggestions.

Do not paint on Practice Project pages. This would damage the pages and spoil your book. If you wish to paint with watercolors you can obtain appropriate papers or pads at an art supply store. For oil paints you can get canvas, canvasboards or textured paper.

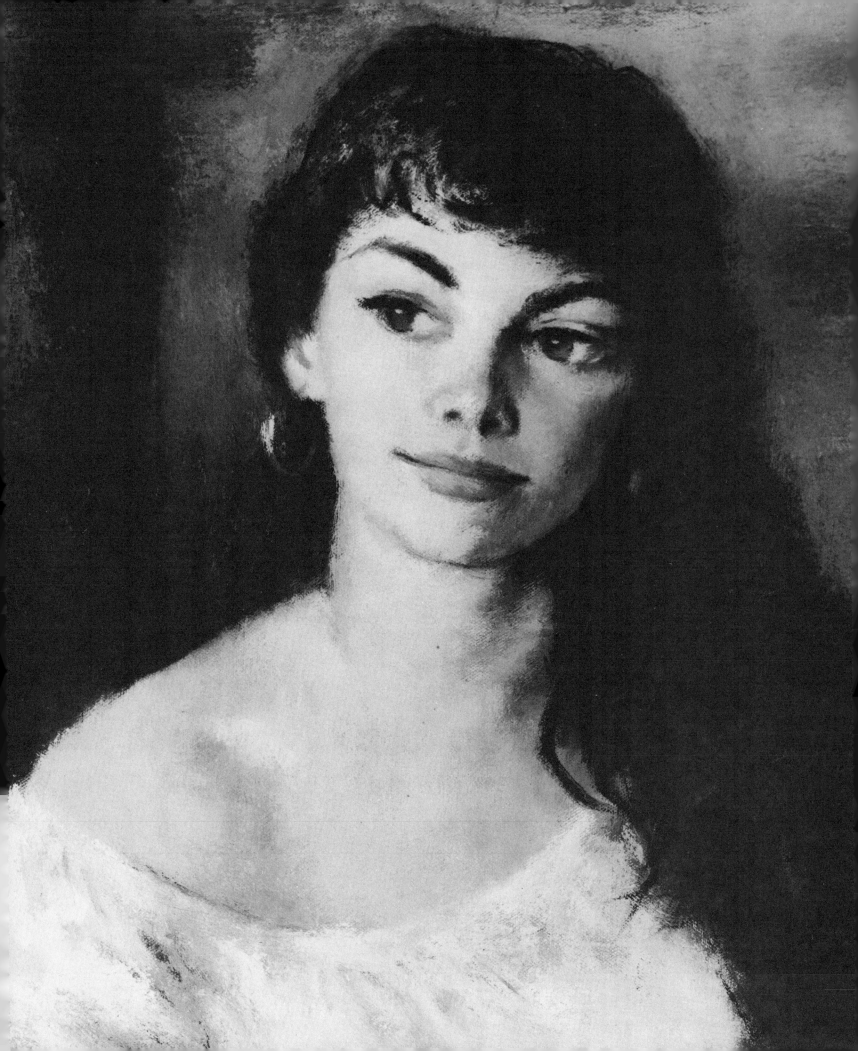

The Pleasures of Portraiture

When you take up your brush to paint a portrait you join a community that includes some of the greatest artists who have ever lived.

Portraits are among the most fascinating and best-loved pictures in the world. Leonardo's *Mona Lisa*, Gilbert Stuart's portraits of George and Martha Washington, Rembrandt's self-portraits, Van Gogh's paintings of his friends and himself—these are just a few of the treasures of portraiture. For the artist, the human face is one of the most engrossing of subjects, and he has poured forth his greatest skill in portraying it.

In these pages we show you how to draw and paint the human face. Step by step we explain to you the techniques of creating portraits in watercolor, oils, and other popular mediums. These are described to you simply and understandably by some of America's best-known and most popular successful artists. They reveal to you their tricks of the trade and describe their professional secrets with the help of scores of specially made photographs, diagrams, and explanatory drawings that take the mystery out of portrait painting and make it easy to learn.

As you follow our simple directions, you will find yourself looking at every face you see with fresh eyes and new interest. And if you study these pages carefully and apply the knowledge they impart, before long your friends, relatives, and acquaintances may be begging you to draw and paint their portraits, as a whole new world of pleasure and profit opens up to you.

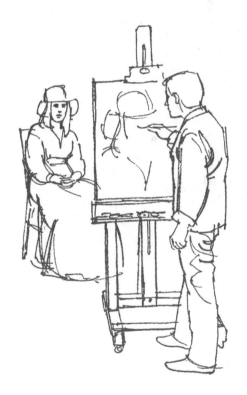

 The young woman's head (*left*) is a detail from a portrait by the well-known artist Ben Stahl. Note how skillfully Stahl posed his model to make the most of her languorous smile and her luxuriant hair.

Working Tools

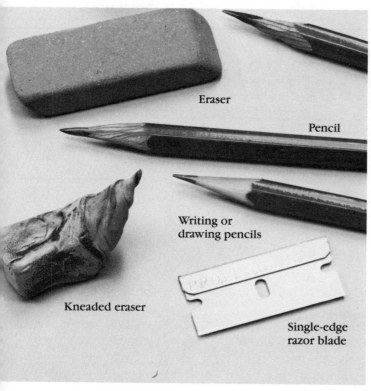

Eraser

Pencil

Writing or drawing pencils

Kneaded eraser

Single-edge razor blade

Pencils. *Ordinary writing pencils* are fine for Practice Project drawings. They come in grades ranging from soft to medium and hard leads. The soft pencils give you broader, darker lines and tones. The harder pencils produce grayer lines but can dig into your paper. They are best used for transferring drawings as shown on page 80. Pencils used by professional artists come in a variety of leads ranging from 6B (very soft) to 9H (very hard).

How to sharpen pencils. *A regular pencil sharpener* gives a sharp, even point. You can also sharpen your pencil with a single-edge razor blade and finish shaping the point on a sandpaper pad or any fine grain sandpaper. For a wide, chisel-like point, rub the point on the sandpaper without rolling it.

Erasing. *A medium soft eraser* such as a pink pearl or the eraser on the end of a writing pencil is good for most erasures. Another useful type is a kneaded eraser which can be shaped to a point by squeezing it between your fingertips.

Charcoal. *This wonderfully responsive medium* comes in three forms. First, there is the natural charred stick commonly called "vine charcoal." Then there are two synthetic forms. One is made into a pencil and the other comes as a chalk about 3 inches long. All three forms come in varied degrees of softness (blackness). Natural charcoal is the most subtle and it erases most easily, using a kneaded eraser. The pencil kind is the least brittle and cleanest to handle.

Papers. *Drawing papers have different surfaces*—slick, medium and rough (artists refer to the latter as having "tooth"). The Practice Projects are planned so you can draw directly on them. You will also find sheets of white drawing paper and transparent tracing paper at the back of the book. For additional practice sketching, typewriter paper is good. A pad of common newsprint can be purchased at an art supply store where you can also get white and tinted charcoal paper. Another good type of practice paper is a roll of commercial white wrapping paper (but be sure it is not the kind with a wax surface).

Easel or Drawing Board. *Fasten your paper with tape*, thumbtacks or push pins to any light, firm board. Put a smooth piece of cardboard or several thicknesses of paper under your top sheet so rough or uneven spots on the board won't interfere with your drawing. An easel is fine to support the board but you can prop it in your lap and either hold it with your outstretched arm or rest it against any firm object. Another good method is to prop the board on the seat of a straight-backed chair. The seat then makes a good place to hold pencils and erasers.

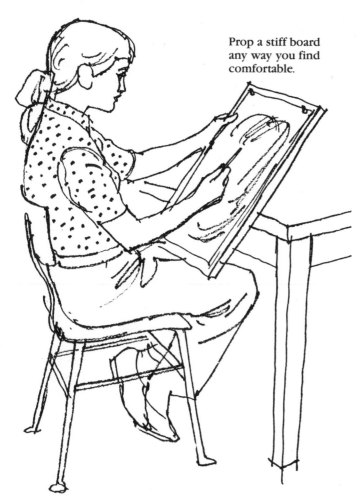

Prop a stiff board any way you find comfortable.

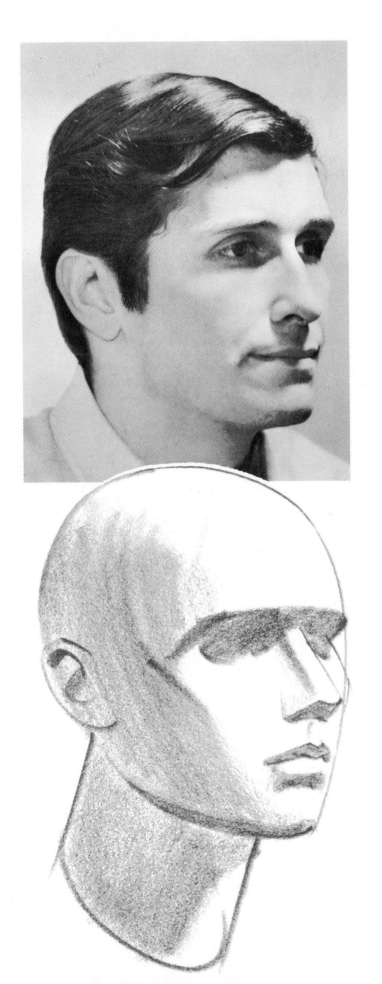

The Head

The correct shapes and proportions of the facial features are essential to a good portrait. The head, however, is not an assemblage of separate parts but a simple, solid form.

Basically it is egg-shaped, with the small end at the chin. To this add the protuberance of the nose. The eyes are set in under a usually overhanging brow. With the positioning of ears and mouth the transformation from egg to head is well under way.

Once the solid form of the head has been sketched in, the correct location of the features can be established as indicated below.

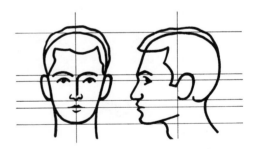

How to place the features

The eyes are on an imaginary horizontal line about halfway between the chin and the top of the head. The bottom of the nose is about halfway between eyebrows and chin. Place the mouth about one-third of the way between the nose and chin.

The side view shows that the eye is placed *back* from the front of the face. Locate the ear just behind a vertical line halfway between the front and back of the skull.

9

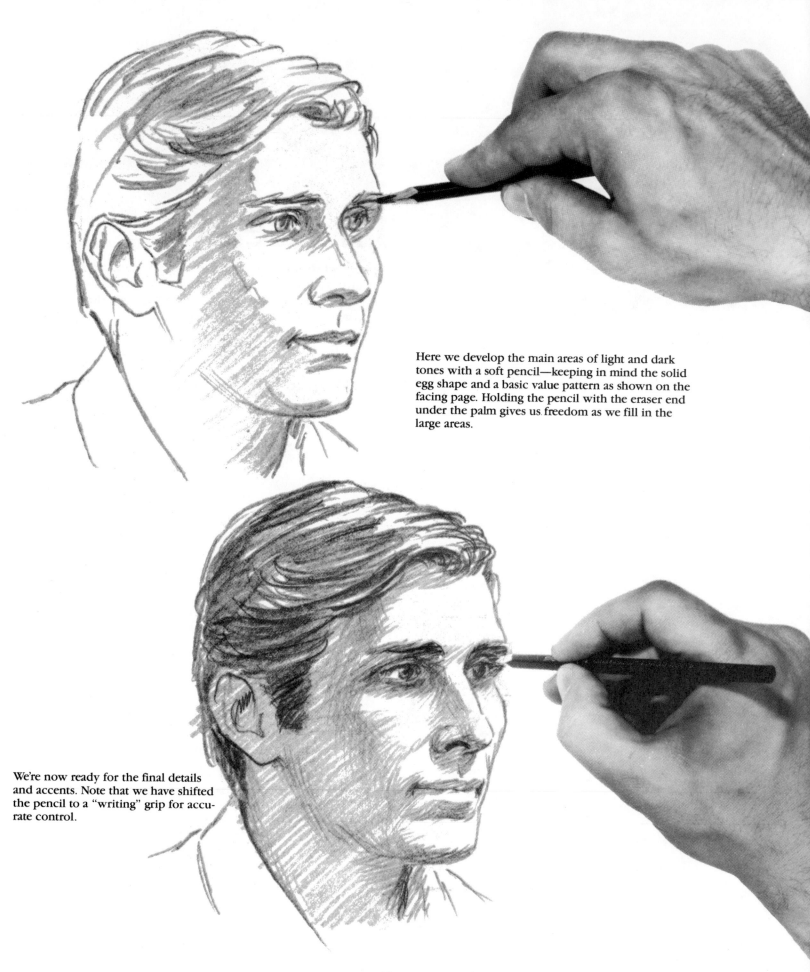

Here we develop the main areas of light and dark tones with a soft pencil—keeping in mind the solid egg shape and a basic value pattern as shown on the facing page. Holding the pencil with the eraser end under the palm gives us freedom as we fill in the large areas.

We're now ready for the final details and accents. Note that we have shifted the pencil to a "writing" grip for accurate control.

How to Draw a Head in Pencil

This demonstration shows you a logical way to make a finished pencil drawing of the head shown on page 9. We start with a careful line drawing. Remember that it's easier to erase and correct the first light pencil lines than to change more detailed drawings later on. We then develop the "values"—by which is meant the dark and light tones—using broad parallel lines. We finish by drawing the details.

Remember: main shapes first—details last—in any drawing or painting.

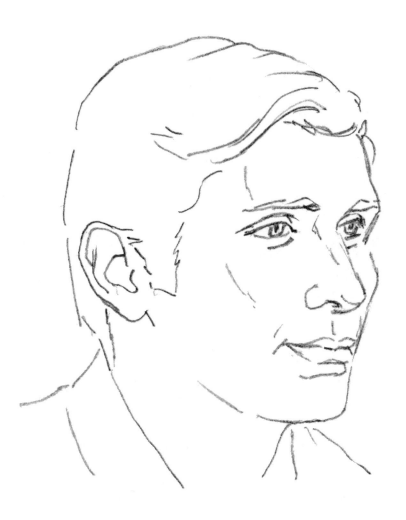

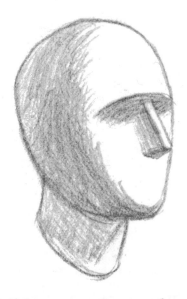

Things to remember. *The basic egg shape* should always be kept in mind, even when you are concentrating on details of personality and expression.

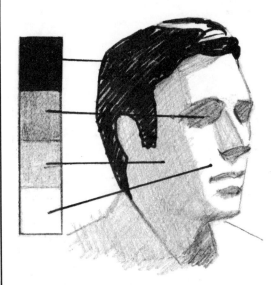

Practice Project

Working directly on this page complete the above drawing. Use a soft pencil. Don't copy the drawing on the preceding page stroke for stroke but try for the same overall effect, using broad, sweeping strokes for large areas of shading and careful, precise strokes for details.

Value Pattern. It's important to establish a simple basic pattern of black, white, and one or two gray half tones to give your drawing structure and solidity. (More about this on pages 40 and 41.)

Section 2
Constructing the Basic Head

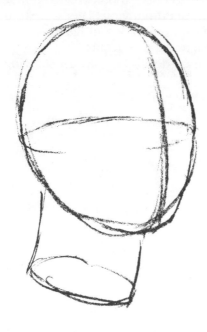

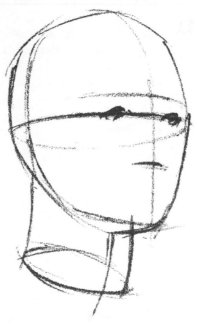

1 Begin by sketching the basic egg-shaped form. Pay attention to the gesture that determines the tilt and thrust of the form. Here we have a three-quarter view. Note that the neck is not an absolutely vertical column but thrusts slightly forward.

2 Draw a vertical line to indicate the center of the face and a horizontal line to locate the eyes. Be sure to curve these lines to follow the round form of the egg.

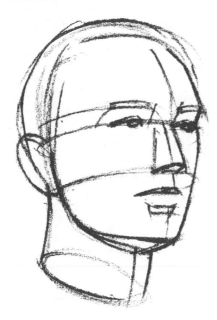

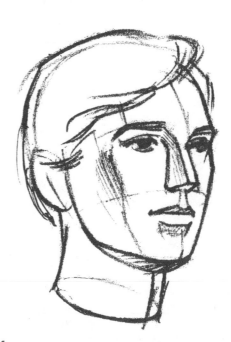

3 A horizontal line just above the eyes and another halfway to the chin give you the top and bottom of the nose. These lines go *around* the head and show you where to place the ear. A curved horizontal line one-third the distance between nose and chin indicates the placement of the mouth.

4 Place the eyebrows and loosely sketch in the hairline at the top of the forehead and around the ear. Remember that the hair is usually a mass that extends above the top of the basic form.

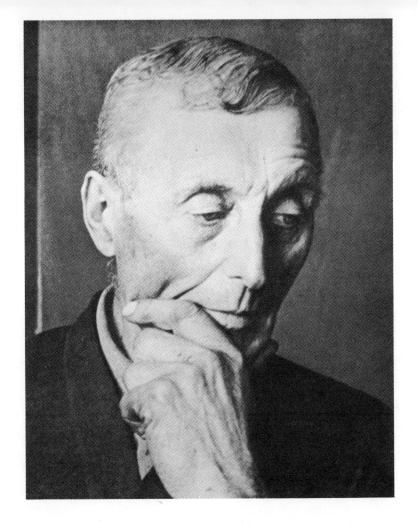

Practice Project...
constructing the basic head

Using the method shown on the preceding page, make a drawing from this photograph. Start with light construction lines and develop the drawing to the same degree of finish as shown in step 4. Don't make a finished drawing. Leave your main construction lines so you can compare them with the Instructor Overlay on page 81.

The Gesture…*the spirit of the pose*

We are all distinguishable from one another by our individual attitudes and gestures. Not only the shape of your head, long and narrow or square and blocky, but the way you turn it, cock it to one side, thrust out your chin—all such idiosyncracies are clues to your personality.

A good way to practice looking for telltale gestures is to make mental or actual quick sketches of people in your home, office, school, on the streets, or in stores.

When working from a posed sitter, make sure your model is comfortable and relaxed. A little conversation will often put the subject at ease and you will then see the natural gestures that indicate his or her individuality.

Let the pencil roam freely on the paper, searching out the flow and rhythm of the forms. Don't get involved in details. Establishing what the various forms are "doing" will help you to express true character.

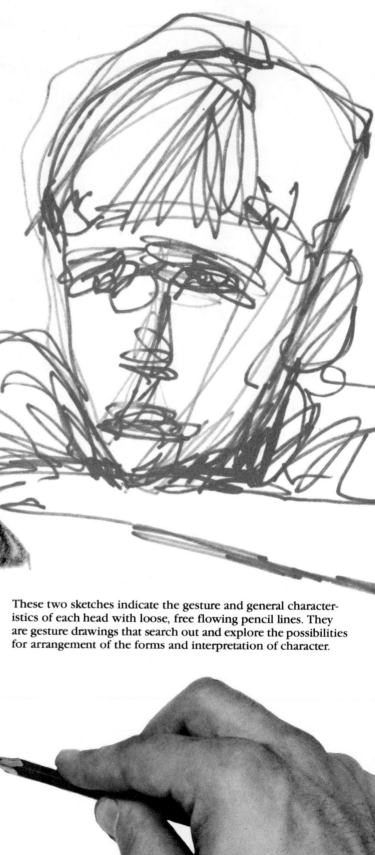

These two sketches indicate the gesture and general characteristics of each head with loose, free flowing pencil lines. They are gesture drawings that search out and explore the possibilities for arrangement of the forms and interpretation of character.

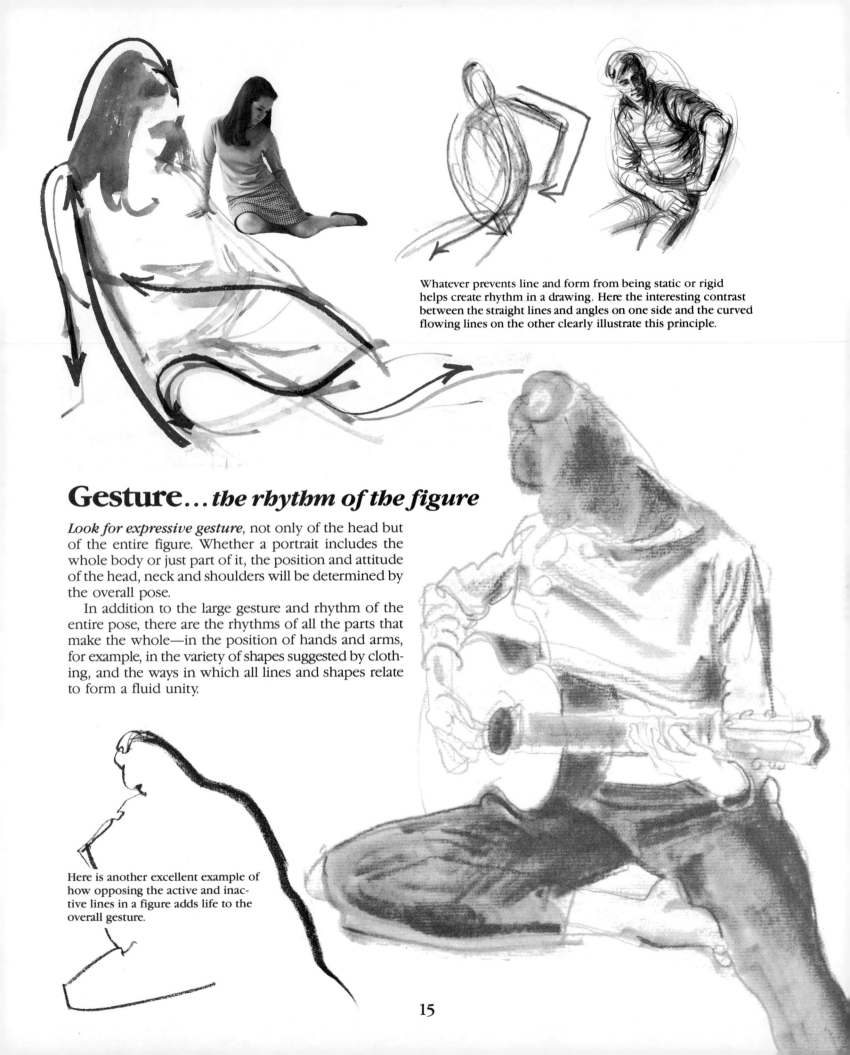

Whatever prevents line and form from being static or rigid helps create rhythm in a drawing. Here the interesting contrast between the straight lines and angles on one side and the curved flowing lines on the other clearly illustrate this principle.

Gesture... *the rhythm of the figure*

Look for expressive gesture, not only of the head but of the entire figure. Whether a portrait includes the whole body or just part of it, the position and attitude of the head, neck and shoulders will be determined by the overall pose.

In addition to the large gesture and rhythm of the entire pose, there are the rhythms of all the parts that make the whole—in the position of hands and arms, for example, in the variety of shapes suggested by clothing, and the ways in which all lines and shapes relate to form a fluid unity.

Here is another excellent example of how opposing the active and inactive lines in a figure adds life to the overall gesture.

Practice Project

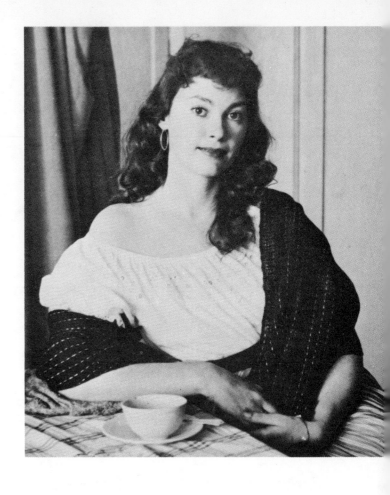

> ***This lovely model will appear several times*** in this book, giving us a chance to study her from a number of points of view—and finally, to see how all of these approaches are used in the finished portrait demonstration by Ben Stahl on pages 44–48.
>
> After reviewing pages 14 and 15, make a gesture sketch, capturing the rhythm and spirit of the pose. Use a soft pencil and sketch freely, without attempting to draw accurate details.
>
> Then turn to page 82 and see how a Famous Artists Instructor interpreted the pose.

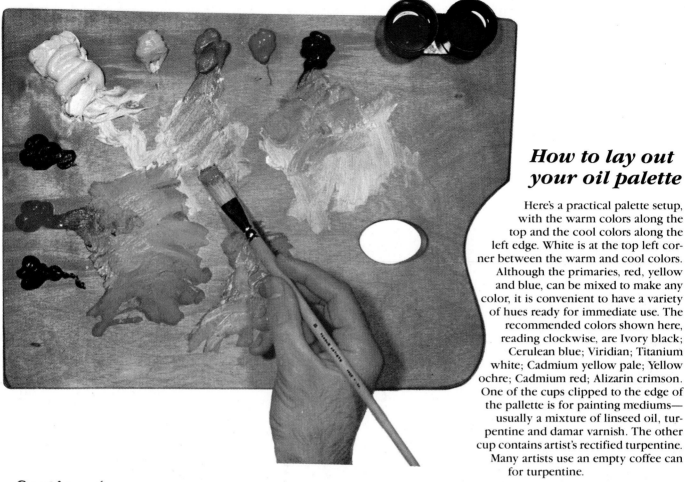

How to lay out your oil palette

Here's a practical palette setup, with the warm colors along the top and the cool colors along the left edge. White is at the top left corner between the warm and cool colors. Although the primaries, red, yellow and blue, can be mixed to make any color, it is convenient to have a variety of hues ready for immediate use. The recommended colors shown here, reading clockwise, are Ivory black; Cerulean blue; Viridian; Titanium white; Cadmium yellow pale; Yellow ochre; Cadmium red; Alizarin crimson. One of the cups clipped to the edge of the pallete is for painting mediums— usually a mixture of linseed oil, turpentine and damar varnish. The other cup contains artist's rectified turpentine. Many artists use an empty coffee can for turpentine.

Section 4

How to Mix and Use Oil Colors

To become thoroughly familiar with your oil palette, start right in mixing pigments. Begin with two colors plus white. By varying the proportion of one of the pigments you produce a new color. With just a few colors, plus black and white, you can make limitless combinations.

The resulting colors—such as the secondary and intermediate colors—are discussed on the next two pages. Note that with oils you use white to lighten your colors instead of relying on the white of the paper as in watercolor. These color mixing principles also apply to opaque watercolor (gouache) and polymer acrylics when used in a thick, opaque manner.

Oil paint can be used on paper, wood, or other surfaces, but canvas is usual for finished pictures. Canvas board and canvas textured papers are related alternatives, the latter being useful for practice. Bristle brushes are the most common painting tools. You'll need a variety of sizes. Sable and other soft-haired brushes are handy for smoother effects and details. You should also have a flexible palette knife to use in painting and mixing. A small one, called a painting knife, is popular with many artists, who employ it for some or all of their painting.

Clean the mixing area of your palette after every working session, scraping off the paint and wiping the surface with a turpentine soaked rag. The piles of unmixed paint can be left for days. They may form a dry outer skin but when this is removed the paint underneath will still be soft.

Palettes are generally made of wood, like the one shown here, but a piece of glass or other hard, smooth-surfaced material such as masonite will do as well. Another type is a commercially available pad of waxed tear-off sheets shaped like the conventional wooden palette. Arrange your pigments as shown above, with an extra generous mound of white. With brushes or palette knife pick up small amounts of pigment and mix them in the center of the palette. Have rags handy to wipe your brushes. Rinse them with turpentine.

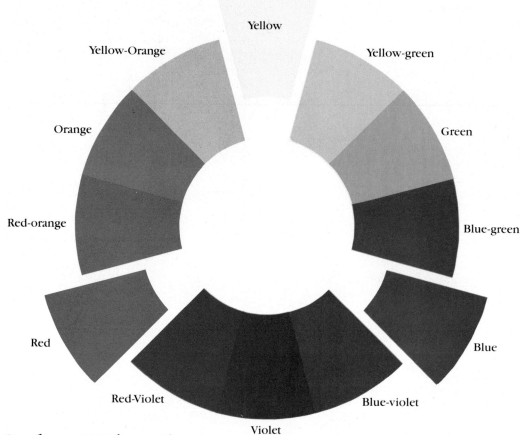

Yellow

Yellow-Orange · Yellow-green

Orange · Green

Red-orange · Blue-green

Red · Blue

Red-Violet · Blue-violet

Violet

The Color Wheel

Hue is the word used to name a color. The color wheel shows how hues are related.

 Red, yellow and blue are called the primary colors. They cannot be made by mixing other colors but all other colors are made by mixing the primaries.

 Mixing any two of the primaries results in a secondary color. The secondaries are green (blue and yellow), violet (blue and red), and orange (red and yellow). Other colors can be made by mixing the secondaries together or with the primaries.

 Two other useful terms pertaining to color are *analogous and complementary.* Analogous colors are those next to each other on the color wheel. Complementary colors are directly opposite each other on the wheel. Thus orange is analogous to red-orange while it is complementary to blue.

Some colors seem Warm...others seem Cool

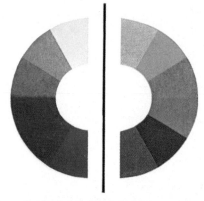

The hues in the left half of the color wheel are considered warm, those in the right half cool.

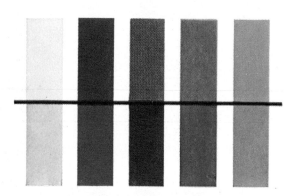

Each bar contains a warm and cool variation of the basic color. The upper half is cool, the lower half warm.

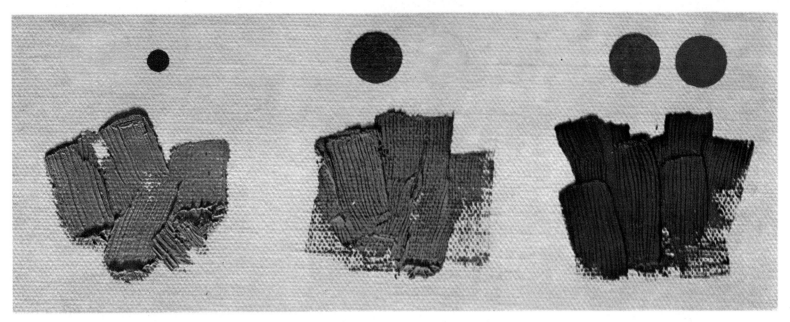

How to mix Secondary Colors...orange, green and violet

Combining two primaries will produce a secondary color. The three secondaries are orange, green, and violet.

To mix orange, pick up some of your yellow and place it in the center of your palette. Now wipe your brush or knife.

It isn't necessary for your brush to be thoroughly clean when you pick up a little of another color. Just swish your brush in some turpentine and wipe on a rag. Only when you switch to a completely new color mixture will you need to clean the brush more thoroughly. In that case, wash it in the turpentine, wipe on a rag, and repeat this a number of times.

Now pick up a small amount of red and mix it with your yellow. The proportions shown above will help you. In any of your mixing procedures, *add the lesser color in very small amounts at a time* until the mixture produces the color you want. This is one place where you should be stingy.

Next dip your brush (or knife) lightly into your painting medium and stir a little of this into your mixture. Now brush a few strokes of your orange on a sheet of canvas textured paper or board.

Next, for green, combine some yellow and approximately the same amount of blue.

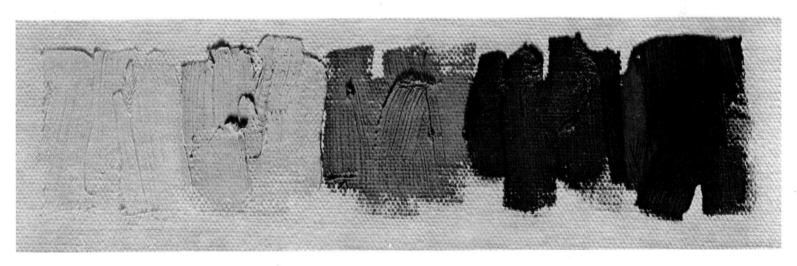

Intermediate Colors...the "in-betweens"

This term refers to hues mixed from two primaries, but leaning strongly toward one of them. Here we see how different proportions of yellow and blue will produce yellow-green, green and blue-green. In a similar way we can start with yellow and red to produce yellow-orange, orange and red-orange. Similarly we can use red and blue to produce red-violet, violet and blue-violet.

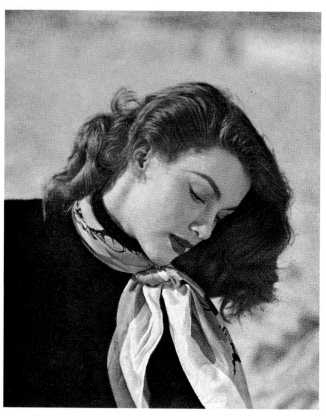

How to Mix Colors in a Portrait

Color contributes not only to the life-like appearance of a portrait but also to the illusion of volume and depth in creating solid form.

Avoid the mistake of thinking that a face is a simple "skin-color" that can be applied all over like pancake make-up. The light, dark and halftone values that define form vary widely in color. Within each of these areas there are subtle variations. The lights are usually warm, the darks cool.

This demonstration shows how to organize color areas in terms of tonal values and to see them as warm and cool.

The first step is to give the canvas an all-over tone of a neutral color, such as raw umber mixed with a little white and turpentine. Over this, sketch in the basic drawing.

With a few brushstrokes paint in the dark areas of the hair, sweater and flesh using the color mixtures shown at right.

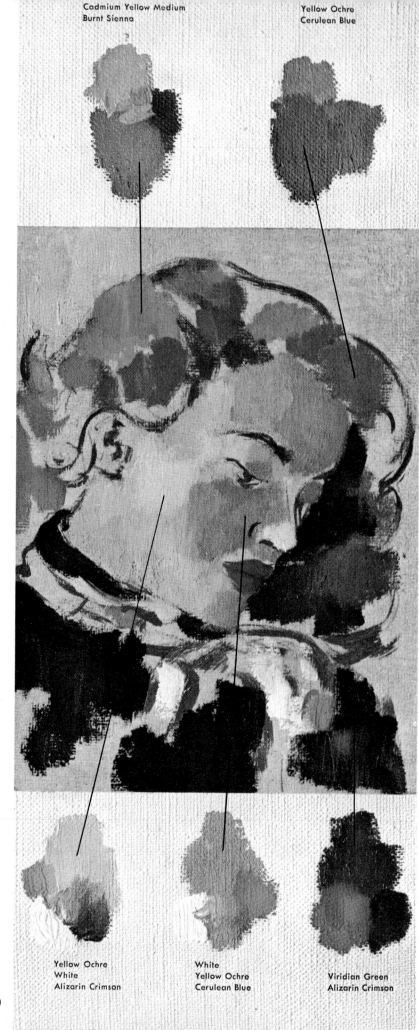

Cadmium Yellow Medium
Burnt Sienna

Yellow Ochre
Cerulean Blue

Yellow Ochre
White
Alizarin Crimson

White
Yellow Ochre
Cerulean Blue

Viridian Green
Alizarin Crimson

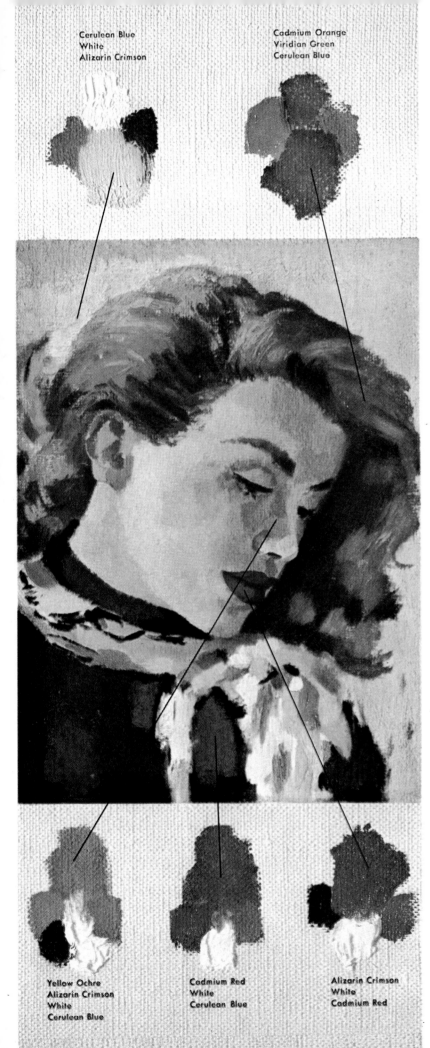

Cerulean Blue
White
Alizarin Crimson

Cadmium Orange
Viridian Green
Cerulean Blue

Yellow Ochre
Alizarin Crimson
White
Cerulean Blue

Cadmium Red
White
Cerulean Blue

Alizarin Crimson
White
Cadmium Red

Now introduce the lights. Note that colors are laid in as areas of light and shadow. Keep the edges between them soft by slightly blending. Pay attention to the subtle variations of color within each area.

Since the halftone areas make the transition between lights and shadows, they are neither obviously warm nor cool. You cannot, however, produce halftones by simply brushing lights into darks. They are subtly colored grays that call for careful observation.

The final steps of completing the portrait involve whatever adjustments in value and color may be needed, and a few accents to point up such details as ear, eyes and lips. Add highlights to spots that reflect the most light, such as the top of the hair and end of the nose, but note that no place in the face is pure white. The lightest lights appear so only because they are surrounded by values that are less light.

21

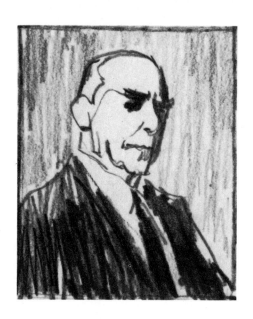

How to Paint a Man's Portrait in Oils

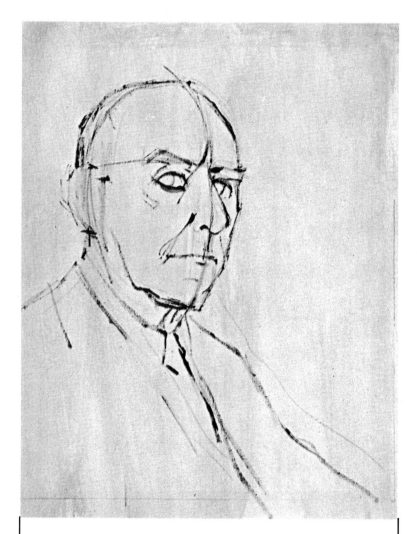

1. Drawing in the head

First we tone the canvas with a thin turpentine wash of raw umber and cerulean blue. Then we sketch in the head as a simple basic egg form. We place the features as accurately as possible in relation to one another, but don't draw them in detail. We concentrate on establishing the proportions of the large forms.

The following pages demonstrate one good way to go about painting a portrait. The initial steps involve all that has been explained so far about basic form, gesture and placing the features. To this we'll apply the principles of mixing colors.

This painting is the type that would be appropriate for a portrait of a company executive—serious, solid and disciplined. Our subject is the well known illustrator, Albert Dorne, who started and was the first president of Famous Artists School. The photograph at left shows the pose we'll use. The lighting is simple. It models the head and emphasizes its form. The sketch under the photograph indicates the value pattern that the painting will follow.

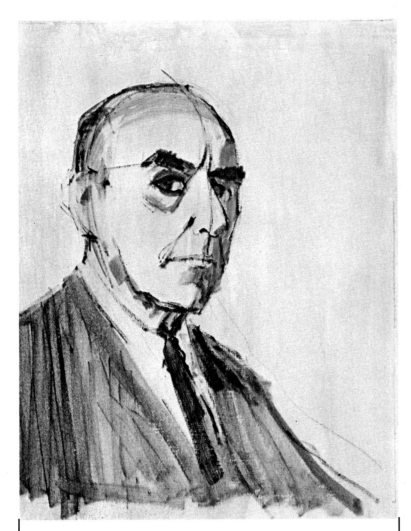

2. Laying in the darks

In umber we indicate the main shadow areas of the head to build its *solid* form and establish the overall value pattern. We need not worry about exact color yet. Careful study shows us that the dark accents of the tie and distinctive eyebrows will be important in the final painting, so we roughly paint them now. They will help us key our values as we go along.

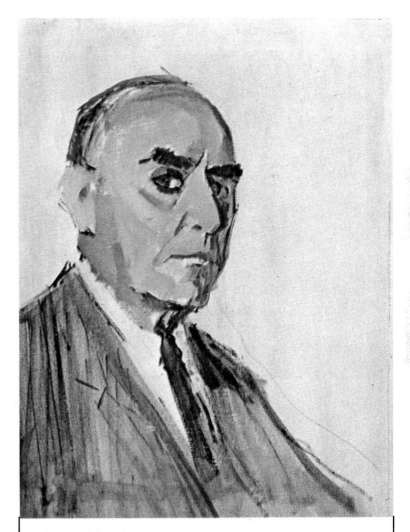

3. Laying in the middle and light tones

Our major concern is still with establishing the solidity of the head. We paint the halftone and light areas broadly, indicating the large planes in values and colors that come fairly close to those of our subject. We're still not too concerned with exact color. We keep the planes simple and avoid any tendency to become finicky or too involved with detail.

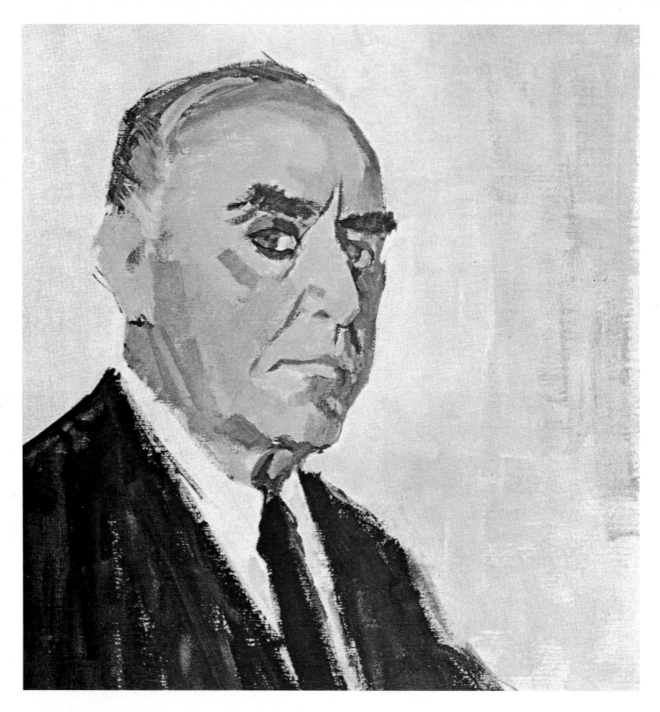

4. Completed lay-in

Let's take a careful look at what we've accomplished so far. The major planes are stated, and we've begun to turn some of the smaller forms like those along the jaw line and around the mouth and eyes. Before we carry the head too far, we brush in some of the background color so we can relate the color of the head to the surrounding areas. The background colors are cooler shades of blue and gray which will work to set off the warmer colors in the flesh. Also at this point we lay in the dark blue of the coat and a dark value for the tie, to further establish the value pattern.

Now we begin to sharpen up some of the drawing which will help create the likeness of our sitter. (Caution: Don't pin down the drawing too much yet!) Notice how the background color is used to define the edge of the shadow side of the head. This edge becomes harder and has more crisp contact where the cheekbone comes close to the surface, but it remains soft in the fleshy areas around the mouth. This variety of edge treatment not only adds interest and vitality, it also gives a greater feeling of reality and form to the head.

The touch of gray is added to the hair. At this stage, it's little more than a color reminder; in later stages we'll refine this area and give it more of the character we want. Now we're ready to start pulling the painting together.

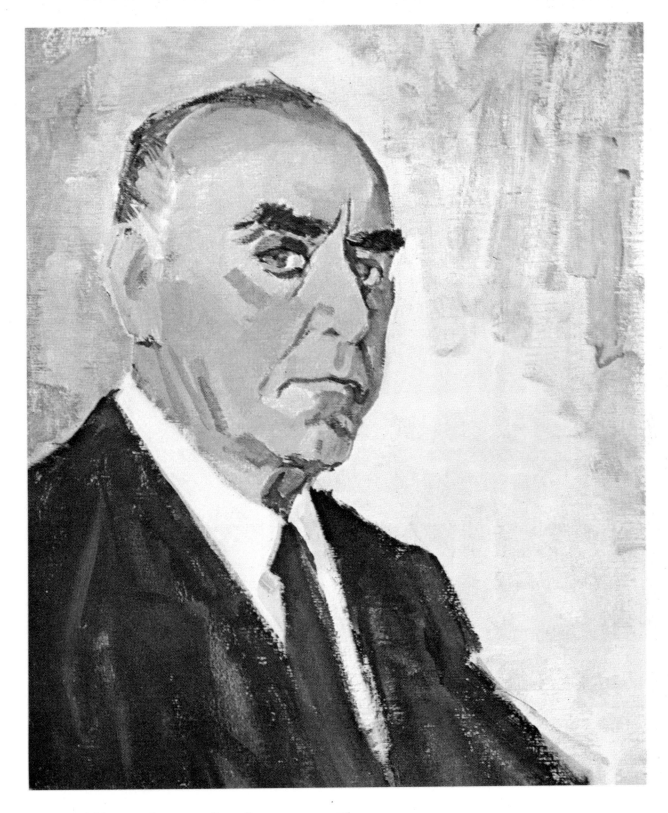

5. Pulling the painting together

With the major areas blocked in we work all over the picture, modifying and adjusting color, value and texture.

Darker values in the background set off the color and value of the head. Now we model some of the smaller forms like the ear and the area around the nose and mouth. We introduce some dark color variations in the jacket and lay in the light value of the shirt. At the top of the head we pull some warm flesh color from the forehead into the hair to soften the edge and avoid the skull-cap look common in many beginner's portraits.

The painting is still a very broad, fluid statement. It's important to keep the entire picture moving along at much the same state of development. Avoid the temptation to finish up any single area or feature. This is one of the most common pitfalls for newcomers to portraiture.

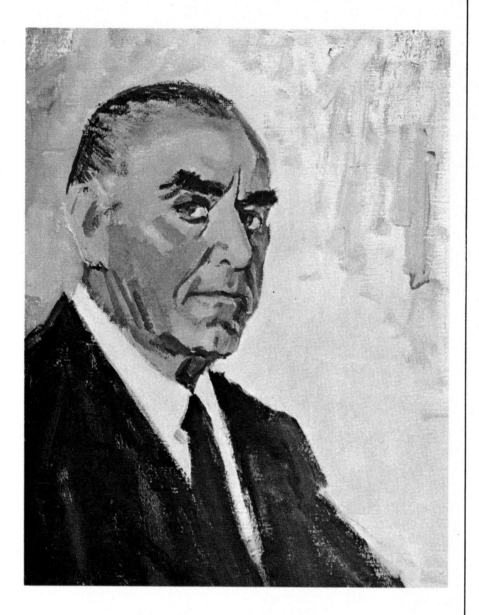

In this full-size replica of the ear at this stage, notice how the brush strokes seem to flow with the form they're describing. Also notice how simply the complex form of the ear is presented. This area won't be developed much further in the final painting.

6. Refining form

Now we begin to work on the refinements. Between the previous stage and this, we've worked only on the head. We've painted the small planes of light and shadow which model the subtle changes of form in areas like the eyes, nose, and chin. Adjustments in value and color are still being made. Compare the shadow under the lip with the same area in step 5. See how we've lightened it. We've done the same to the dark accent on the right cheekbone.

Here is an actual-size detail of the mouth and chin area carried somewhat further. The strength of the form and structure is still very apparent even though the modeling has become more subtle.

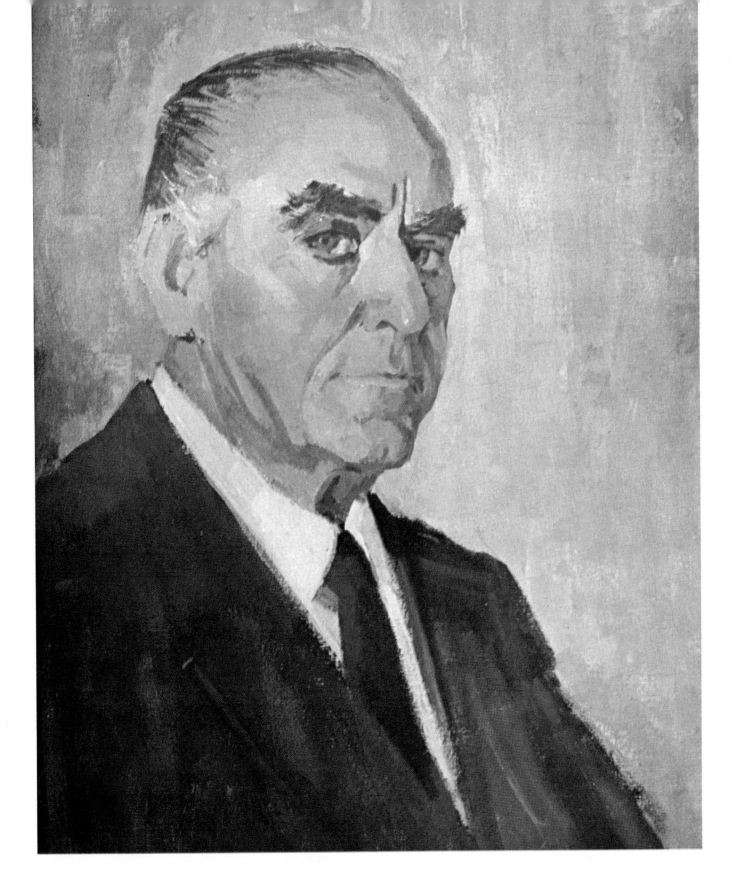

7. The finished painting

As we take the finishing steps we make some changes in the background to create a feeling of space behind the head. Changing the color of the tie to a deep maroon adds important color variety to the painting's lower half. With the addition of a little reflected light in the shadow around the mouth, and a bit more texture in the hair and eyebrows, the commemorative portrait is complete.

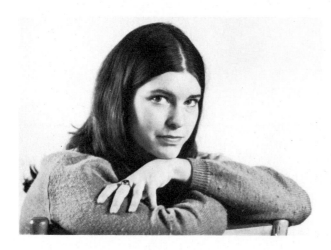

Painting a Woman's Portrait in Oils

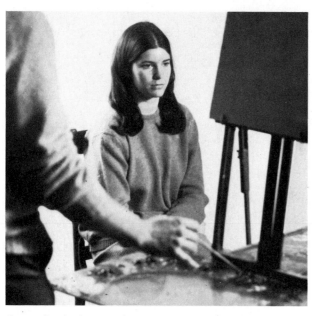

As you begin, be sure that you are close enough to your model to see the colors in her face. Pose her comfortably in good light, arrange your palette, and you're ready for the first step—laying in the background.

Try different color schemes

First of all, try several small sketches in oil on heavy paper to find the color scheme you want. Indicate the main shapes and the position of your model in each of them, but don't worry about details.

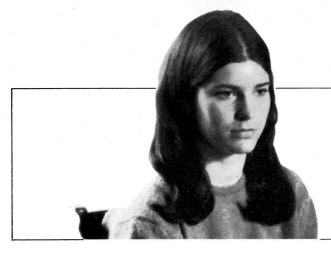

It's usually a good idea to pick as a subject someone you know and like—and someone who likes you enough to sit still for a long time.

Having chosen a female sitter, observe her carefully and think about what you see. What is it that makes her different from everybody else? Watch the way she moves. How does she most naturally sit? As you talk to her, observe her expressions. Think about her most typical moods, her posture, her mode of dress.

She may usually wear casual clothes, but show up to sit for you looking as if she's ready for a party. If you let her do that, you won't get a truthful likeness. Of course if she really always looks dressed up, that's the way she should look in your painting.

These photographs show the subject of our portrait in different positions and moods. The artist who painted her chose a quiet, pensive pose because he felt, after talking to her and watching the way she moved and the expressions on her face, that this was the attitude that best expressed her personality.

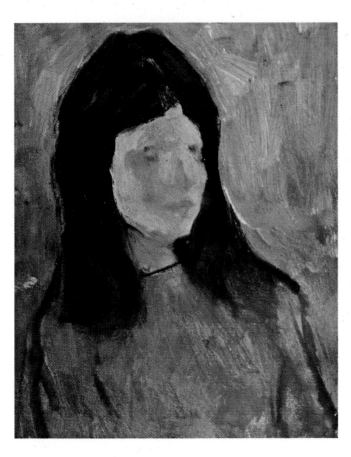

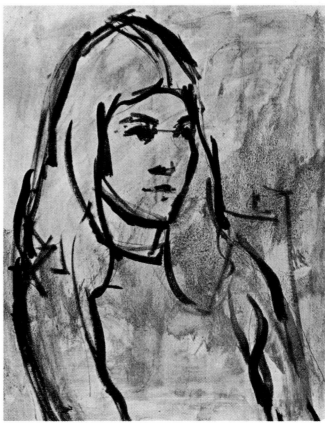

Experiment . . .

Our artist, after experimenting with a number of different palettes, including the very warm one at left, chose a cool color scheme because it seemed to best fit the mood of his model.

1. Draw in the head

Tone your canvas with a very thin wash, then begin your sketch. Don't attempt to make a "nice drawing" here—just establish the main shapes and place the features correctly.

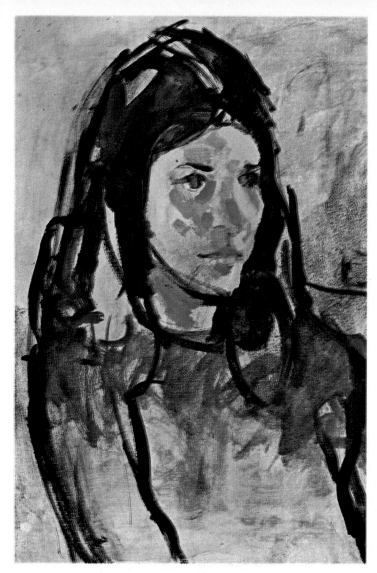

2. Begin the lay-in

Lay in your large masses of color first, with a big brush. A No. 6 long flat bristle would be fine. Notice there is no attempt to paint facial details yet. The strokes of paint on the face establish approximate value and color relationships between the flesh and the darker tones around it. Don't carry the face very far along before you begin to work into the hair and sweater. Because each part of the painting relates to all the others, it's a good idea to keep the whole work progressing at the same rate.

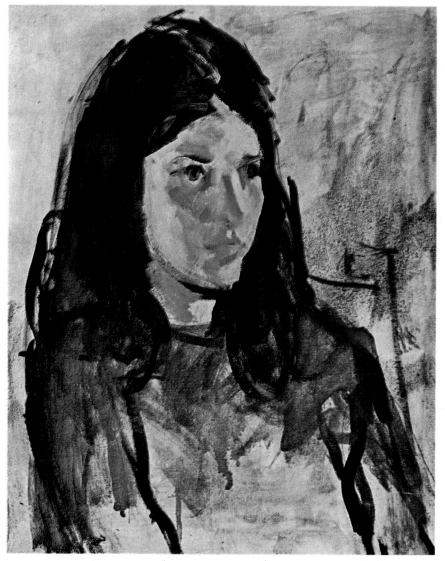

3. Continue the lay-in

Keep comparing one area of the flesh to another for variations in value and color. Don't approach your painting as if you were mixing a single skin tone to apply to the face like makeup. Remember, you're painting the illusion of your model at a specific moment in time as she sits in a definite kind of light coming from a particular direction. *Paint what you see.* The edges where dark and light come together need to be softened a little, but don't lose them. Value contrasts are necessary to describe the planes of the face. Don't just paint the features on. Here the surrounding tones are working into the eye, nose and mouth to avoid a false, painted-on look.

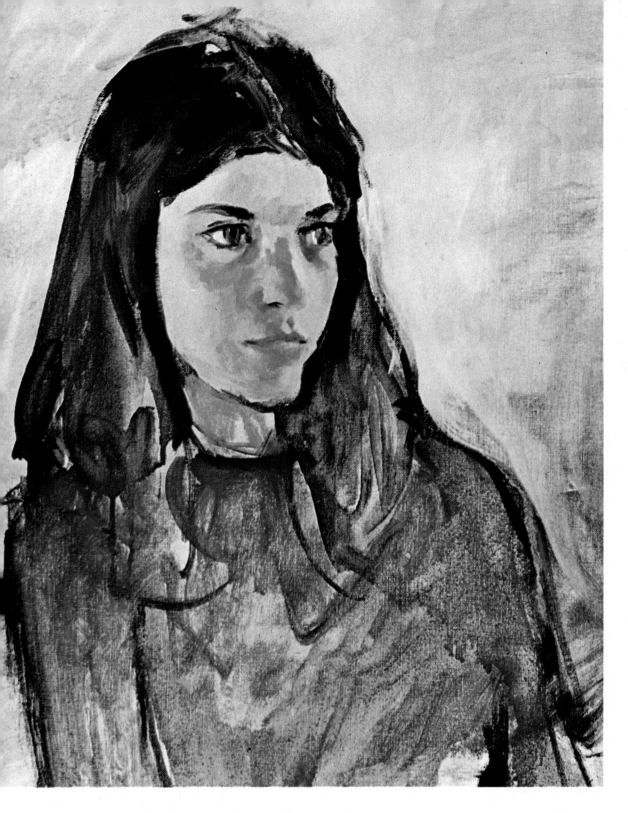

4. Refine the painting

Study the face and make any necessary small changes. If you have a problem in a certain area, it's sometimes worthwhile to scrape off an entire nose or eye or mouth with a palette knife and start afresh. Don't get trapped into niggling with some detail until it's overworked. Often, in the scraping, the problem will be easier to see and correct.

Should you, like many beginners, have a tendency to paint the white part of the eye too light, try painting it with a grayed down tone first and then carefully bring it up lighter with touches of white.

5. Finish the portrait over ▶

Stand back and look at your whole composition. Don't be afraid to make changes if they're needed. When you turn the page, you'll see in our finished portrait that the artist darkened the background to give more contrast to the face. If you aren't satisfied with the background of your painting, work on it some more until you find the value and color that best complement your subject.

If your finished painting has captured your model's personality, as well as a good likeness, you're to be congratulated—for that is what breathes life into a portrait.

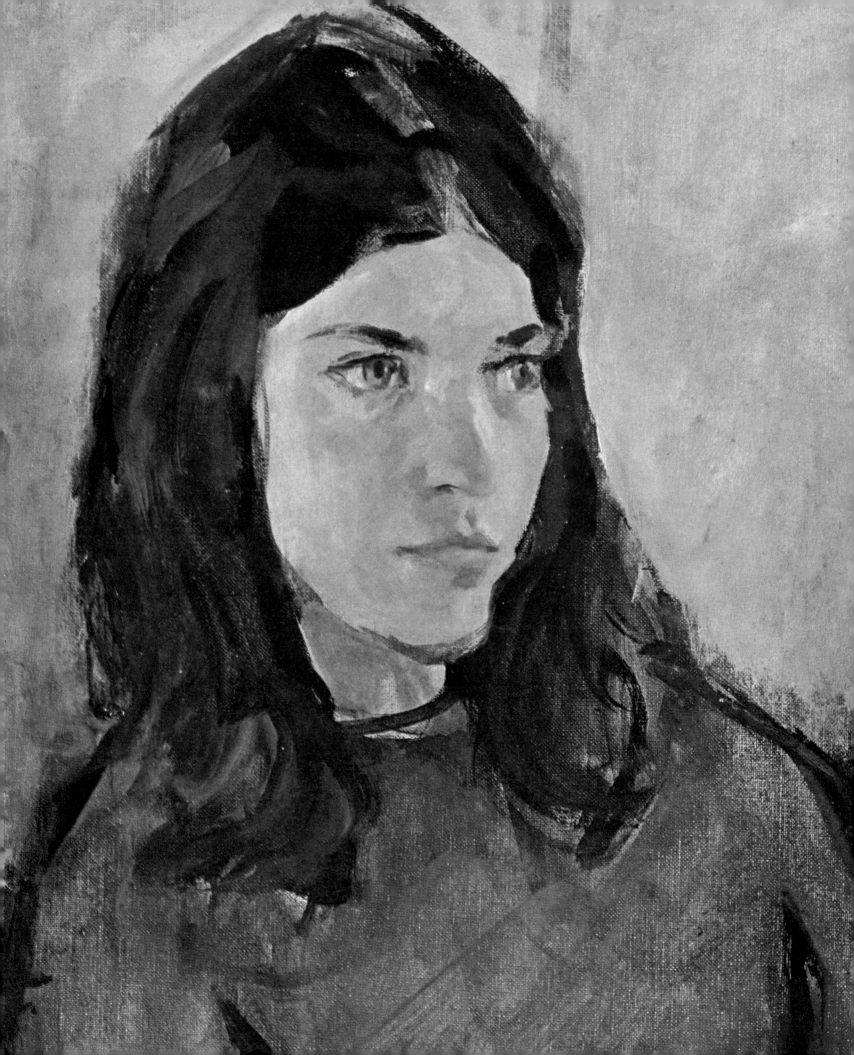

Practice Project

This photograph, with its strong light and shadow pattern, is an excellent model for both drawing and painting.

Pencil Portrait

Work directly over the outline drawing below, using a soft pencil the way you did for the Practice Project on page 11. Then turn to the Instructor Overlay on page 84 for comparison and suggestions.

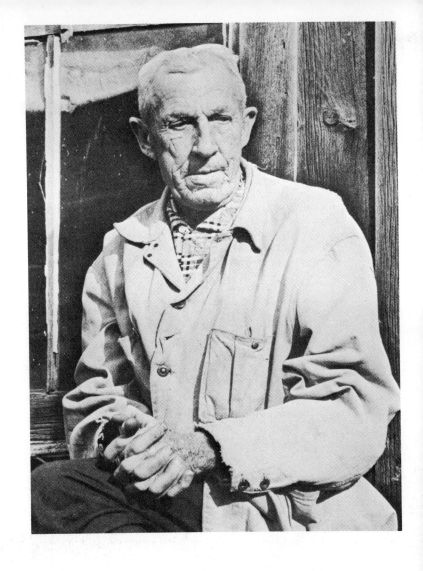

Portrait Painting

With paints, pastels or any other color medium do a portrait on an appropriate surface—canvas or paper. The small diagram might serve as a good compositional pattern. If you need help to get started turn to page 83 where you'll find an outline drawing of this model on tracing paper. Use the method shown on page 80 to transfer the outlines.

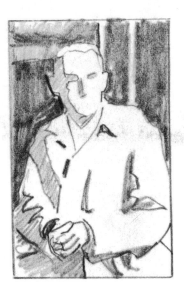

Please Note: You can draw on this page with pencil, charcoal or pastel, but *do not paint on it*, as that would damage your book.

How to Draw the Features...*a closer look*

The eye

The eye is a ball, set into a protective socket and partly covered by the upper and lower lids. The lids come together at the outside corner of the eye, but they don't touch at the inside corner because the little tear duct separates them. Look into a mirror and you'll see that your eyes aren't identical—no one's are. When you observe people's eyes, try to see the slight differences in their shapes and sizes. The slightest change in expression or in the position of the head alters the look of the eye. You have to study your model and draw what you see.

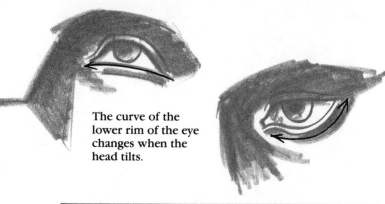

The curve of the lower rim of the eye changes when the head tilts.

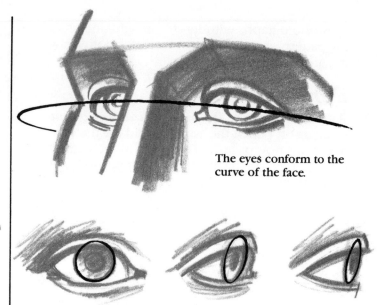

The eyes conform to the curve of the face.

The iris, which is round, looks elliptical as the head turns to the side.

The mouth

The mouth follows the underlying curve of the teeth. It's the most flexible of all the features. In drawing the mouth, the most important, telling line is the one that describes the opening between the lips. This line is never straight.

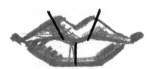

Think of the upper lip as having three sections, the lower lip as having two.

The middle line of the mouth is important for likeness and expression.

The mouth is formed by the underlying curve of the teeth.

The ear

The ear is mostly cartilage. In the middle there is a bowl shape which is surrounded by whorls and curves. Ears vary, but their basic design is always something like the one shown below. Observe not only the size and shape of the ear, but how it attaches to the head. Does it stick out, or is it tucked back snugly?

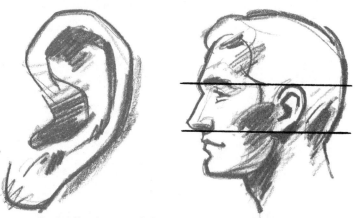

Generally, the top of the ear is in line with the eyebrow, the bottom of the lobe with the tip of the nose.

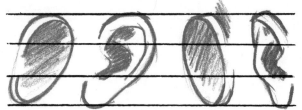

Think of the ear as a simple disk divided into three parts, with the bowl in the center.

How to Draw the Head at Different Angles

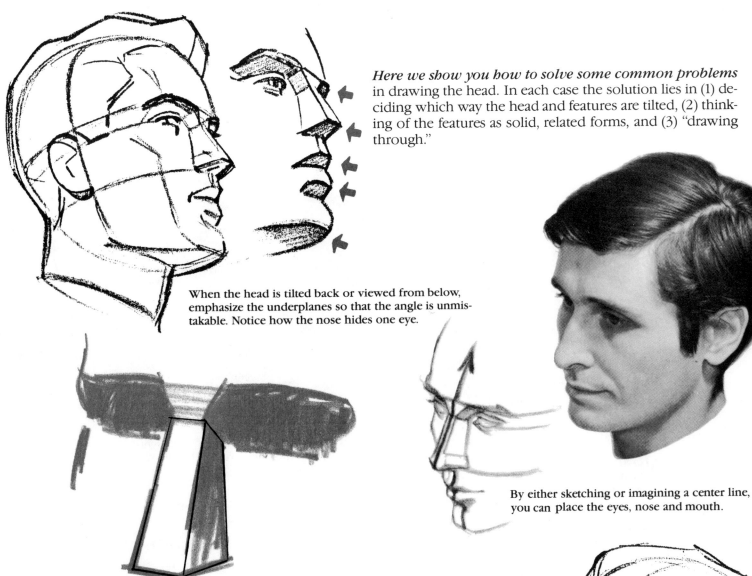

Here we show you how to solve some common problems in drawing the head. In each case the solution lies in (1) deciding which way the head and features are tilted, (2) thinking of the features as solid, related forms, and (3) "drawing through."

When the head is tilted back or viewed from below, emphasize the underplanes so that the angle is unmistakable. Notice how the nose hides one eye.

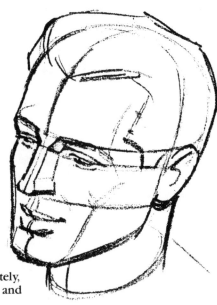

By either sketching or imagining a center line, you can place the eyes, nose and mouth.

The nose

The nose is wedge-shaped, narrow at the top, wider at the bottom. Feel your own nose and you'll see that the upper part has a hard, bony structure, that the lower part is softer. Placing the nose accurately helps establish the angle or tilt of the head.

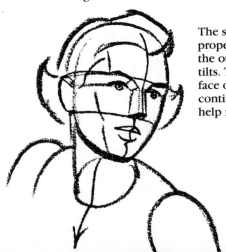

The surest way to construct heads and locate features properly is by means of guide lines "drawn through" to the other side. These lines become ellipses as the head tilts. Think of how a "center line" would follow the surface of the forehead, nose, lips and chin. In any action, continue this line under the chin and down the neck to help relate head, neck, and chest to each other.

When the nose is "blocked in" accurately, it helps establish the eye socket. Eyes and mouth curve around the head.

35

How to Draw Expressive Hands

Next to the face, hands are the most expressive part of the body. They can be gentle and protective or determined and forceful. Expressive hands can greatly enhance a portrait, while hands that are poorly drawn or painted can be a disaster.

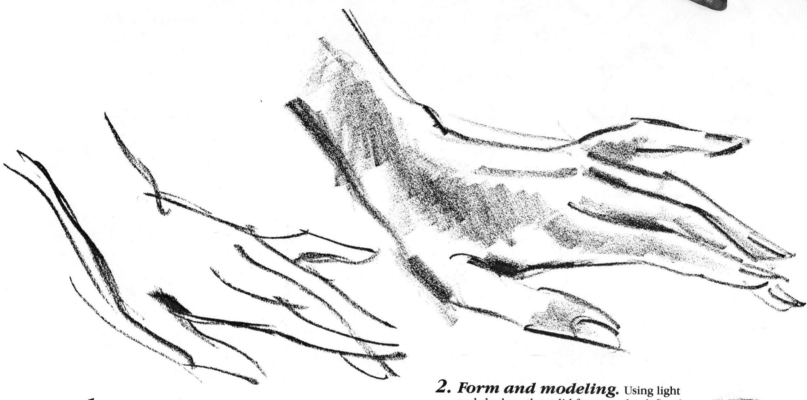

1. Gesture first. Just as in drawing the head, we must capture the expressive flow and spirit of the hand.

2. Form and modeling. Using light and shadow, the solid form can be defined—without losing the basic gesture.

Draw your own hand in different positions—directly first, then from the mirrored image.

Hands are about the same length as the face.

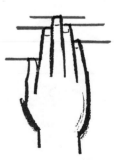

The palm is longer on the thumb side.

Fingers usually vary this way in length.

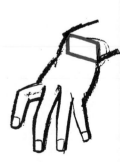

The wrist is solid. Think of this solid form as you draw it.

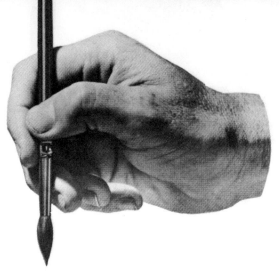

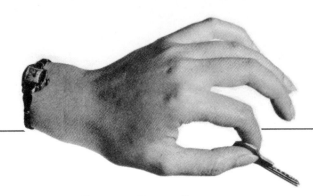

Practice Project...*hands*

Make pencil drawings of both of these hands, following the method shown. Sketch lightly at first, so you can make adjustments and refinements as you go along. You may wish to use the tracing paper method shown on page 80. When finished, compare your drawings with the Instructor Overlay, page 85.

1. Expressive gesture.

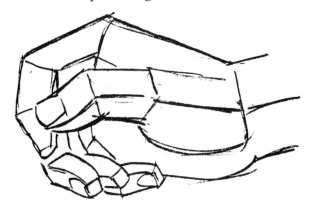

2. Blocking in basic forms.

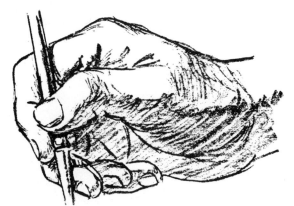

3. Finished drawing, retaining gesture and solid form.

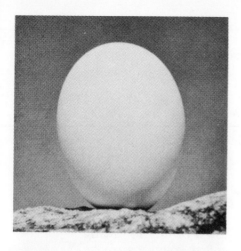

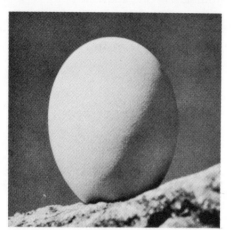

Section 6

Light and Shade on the Head

Our eyes define a form by the light that falls on it and is reflected by it. Put another way, we can recognize the shape of a head, an egg or any solid form by the light that strikes some part of it and the shadow where the light doesn't reach.

The pictures of the egg and the head at the left demonstrate the differences in appearance of forms when light strikes them from in front (top of page); a forty-five degree angle (second from top); the side (second from bottom); and the rear.

When posing your subject, keep the light and shade pattern simple by using a simple lamp or direct sunlight. A single light source causes two clearly defined tones, one light, the other dark, that model the form and make it appear three-dimensional.

Within each tonal area there are ordinarily some subtle variations. The light surfaces turn slightly darker where the form curves away from the light source. And even though shadows seem relatively dark, if you look closely you'll see that there is always some light in them, reflected from surrounding surfaces.

The important thing is to avoid breaking up the large, solid form by introducing tones that are too dark in the light area and others that are too light on the shadow side. Keep in mind the separation of light and shadow areas as demonstrated by the egg. Decide where your light source will be and plan your light and shadow pattern before you begin to draw or paint.

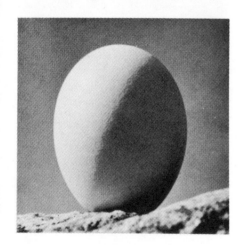

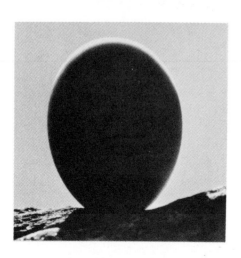

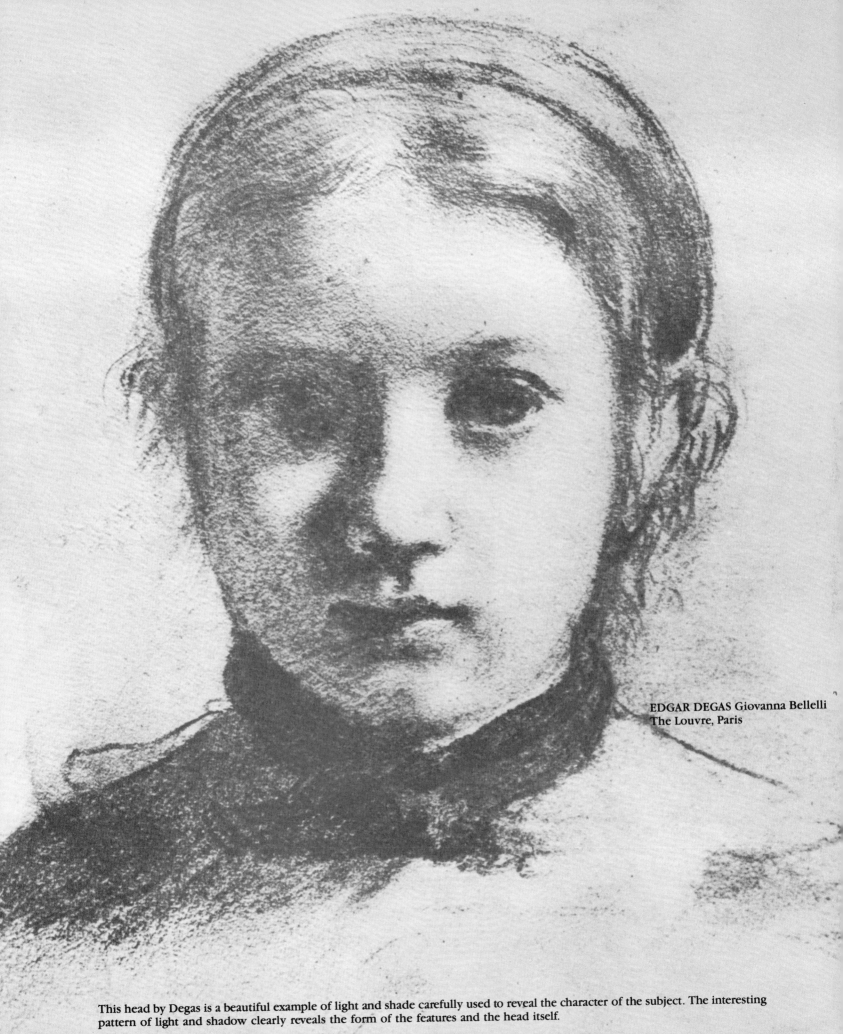

EDGAR DEGAS Giovanna Bellelli
The Louvre, Paris

This head by Degas is a beautiful example of light and shade carefully used to reveal the character of the subject. The interesting pattern of light and shadow clearly reveals the form of the features and the head itself.

Shapes, Values and Edges

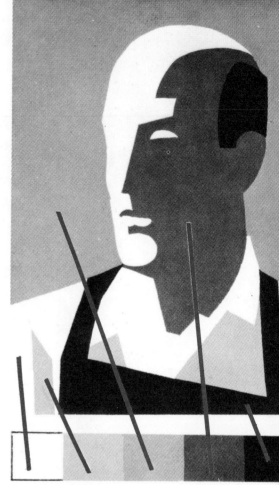

The overall shape of a person or object is its silhouette. Unless we are looking at something against the light we usually don't see it as a single silhouette but as a large shape that contains a number of interior shapes, distinguishable from each other because they differ in tonal value or in color.

Squinting your eyes to blot out confusing details can help you to see the important shapes in a subject and the pattern of dark and light tones they form.

Edges are the boundaries between shapes. It's important to observe whether they are sharp or soft and to paint or draw them accordingly.

Values

This basic value pattern is very simple. The flat shapes of different value resemble the visual effect of the finished painting.

Edges

This close-up shows the sharp edge along the bridge of the nose, the wider edge along the brows and the still wider one between the light and shadow on the skull.

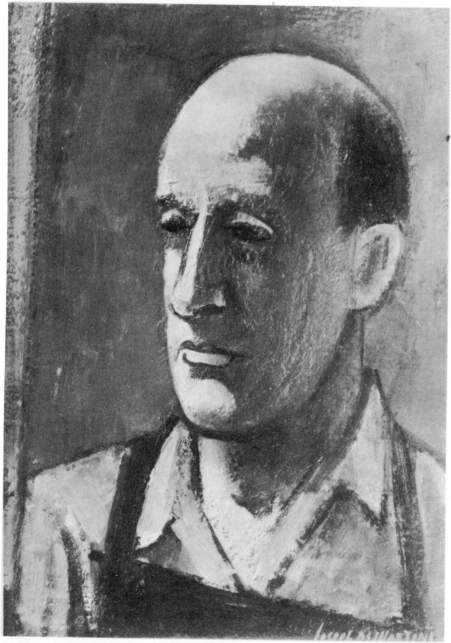

JOSEPH DE MARTINI
Self Portrait
Courtesy of the artist

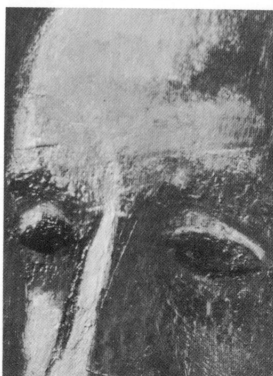

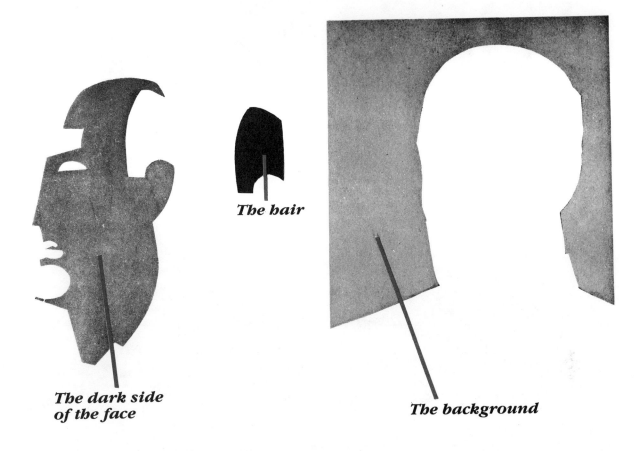

The hair

The dark side of the face

The background

The shapes fit together like a jig-saw puzzle.

By arranging shapes on the flat picture plane to create a solid, satisfying structure, the artist composes a picture. Nearly every effective painting is, first of all, a good composition. Whether it's realistic or abstract, the harmonious pattern of its shapes is what holds it together.

Henry Matisse said: "Composition is the art of arranging in a decorative manner the various elements at a painter's disposal for the expression of his feelings."

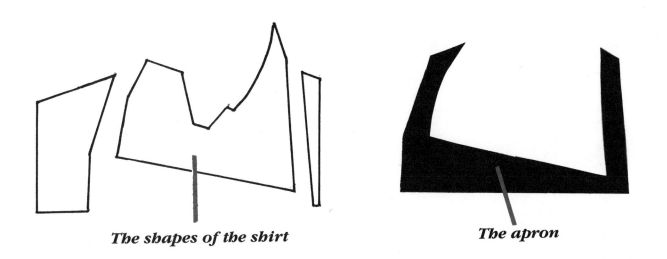

The shapes of the shirt

The apron

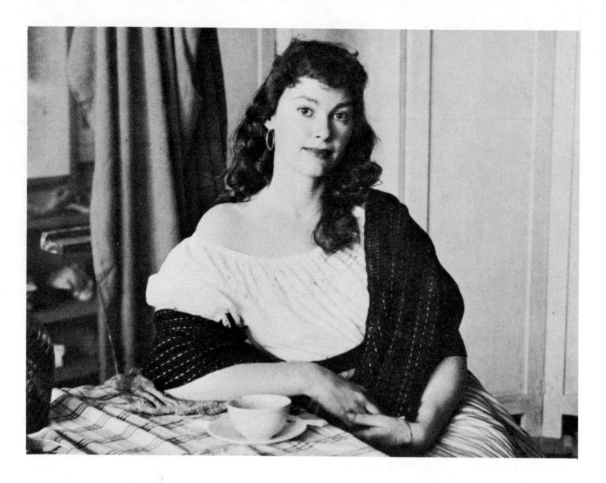

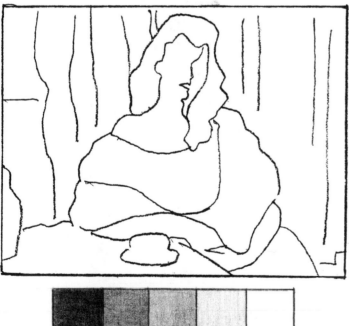

Make experimental value pattern studies in these two diagrams. Use pencil and limit yourself to black, white and the values of gray that are indicated.

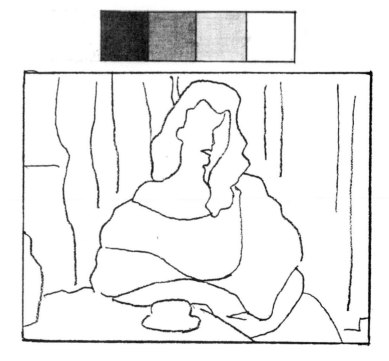

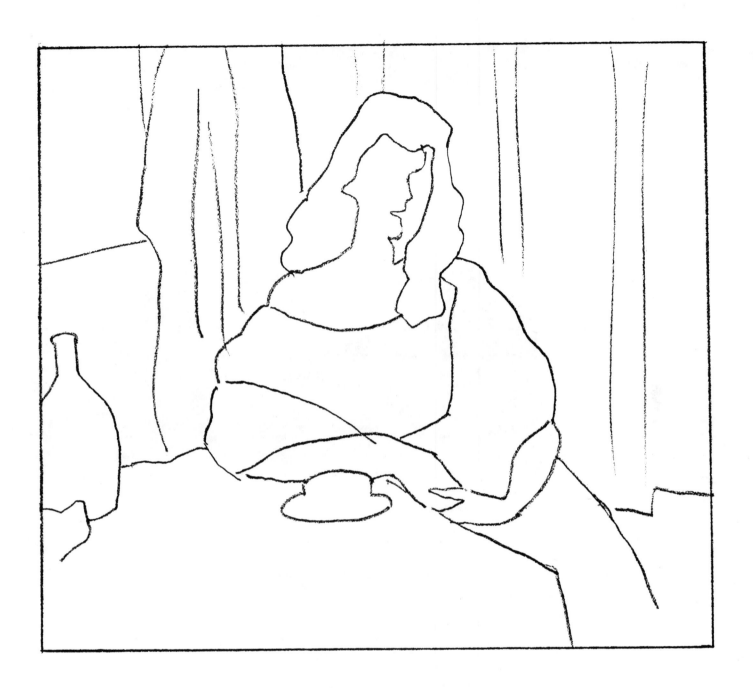

Practice Project...*simplifying the values.*

Here we study the model with the idea of simplifying the values and shapes to form a pattern that relates the drawing of the figure to the background and makes a strong composition.

After reviewing pages 40 and 41, make two value pattern studies with pencil by filling in the shapes in the diagrams on the facing page. Then select the one you consider the most successful and use it as a guide to make a pencil drawing in the frame above.

Then turn to the Instructor Overlay on page 86 for comparison and suggestions.

In the painting demonstration that follows you'll see how the artist creates a strong composition by staying close to his basic pattern of values and shapes.

43

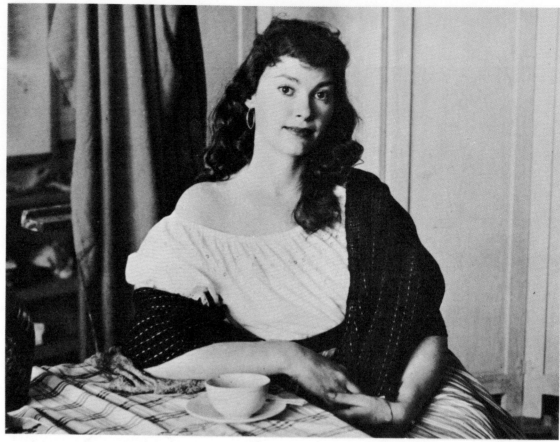

Explore a variety of poses and viewpoints before you start to paint. Make certain the model is comfortable and is in a natural position. This will assure that the pose will be more characteristic of the subject.

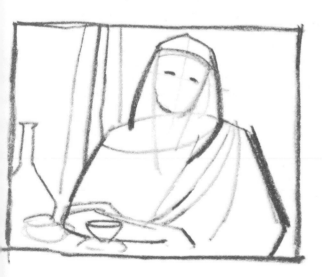

Ben Stahl Paints a Portrait in Oils

On this and the following pages we invite you to the studio of Ben Stahl, one of the founders of Famous Artists School. The demonstrations show how this famous artist paints a portrait.

He believes that it is important to allow the sitter to be natural and comfortable. If the model has particular mannerisms perhaps one of them can be the key to an interesting and expressive pose. When possible pose your sitter in a setting that harmonizes with his or her occupation, life style, or character. Keep the background simple.

To acquaint yourself with the model's natural gestures and general features, make several small pencil or charcoal sketches before you touch brush to canvas. They serve as a warm-up exercise and lead to an exploration of the compositional possibilities of the painting you are about to make. As with every picture, you should try to find satisfying space relationships, value patterns, textures and colors that will make it a success.

The rough placement sketches at the left indicate the kind of probing that leads to a well designed composition. Directly above is a photograph of the pose and setting he finally selected for the painting.

How Stahl uses oil paints

Every artist has his own preferred ways of working. Studying the methods of experienced artists is one of the best ways to find the procedures and learn the techniques that will enable you to achieve your own aims and purposes. With time and practice, you doubtlessly will find the approach and the working methods that suit you best, but you can reach this goal much sooner and with less waste of effort if you have a thorough knowledge of how practiced professionals think and work.

Study the photographs and captions on this page to see what other basic tools and materials Stahl uses, and how he develops his painting.

As a thinning medium and to clean his brushes as he paints, Stahl uses turpentine. Later, he cleans them with kerosene.

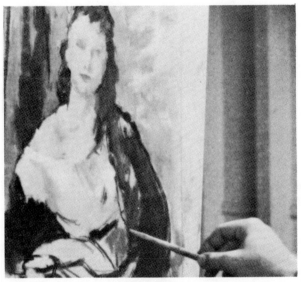

Hold your brush in this manner for full freedom of arm movement.

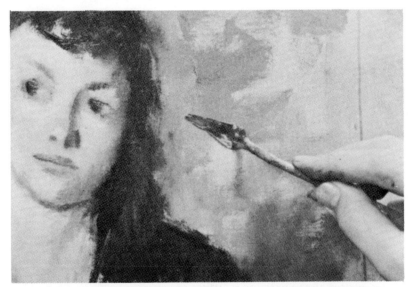

If the paint gets too thick at the beginning, scrape it with a palette knife. Areas requiring thick paint receive it later.

The finger can be useful in softening edges. and to flatten or pull areas together.

A spray of retouch varnish makes the paint set more quickly, allowing Stahl to work into freshly painted areas without picking up the underlying coat.

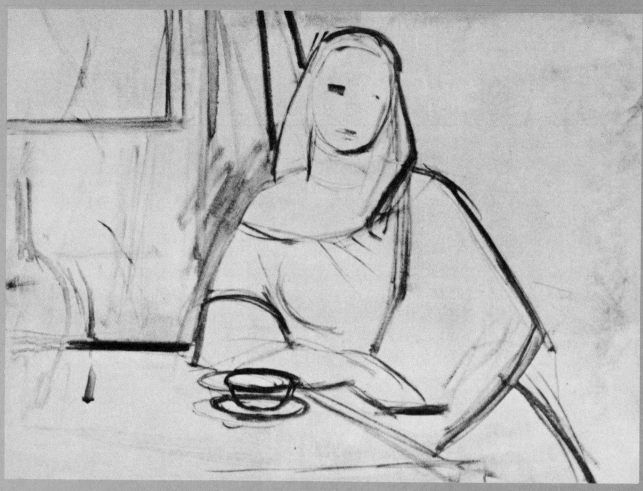

1 Before Ben Stahl begins, he tones his canvas with an all-over wash of umber thinned with turpentine. After the wash is dry, he lays in the general lines of the composition. Notice that at this stage he plans just the big areas of the picture. These are sketched with little regard for nicety of line or delicate draftsmanship. The chief concern is to capture the underlying structure of the picture. No attempt is made to draw eyes, mouth, etc. All that is indicated is the approximate location of the features.

2 Here, Stahl brushes in the big dark pattern and some of the general background toning with a large bristle brush. Next, he works on the shadow side of the face, being careful that the tones on face and background are halfway between the lightest light and the darkest dark. A bit of this lightest light has been irregularly blended (scumbled) on the blouse front for judging the halftone value.

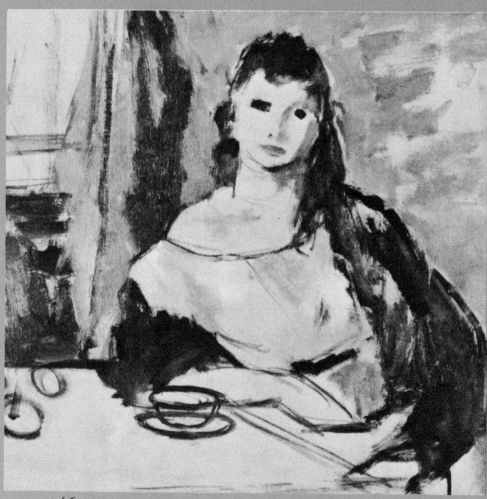

46

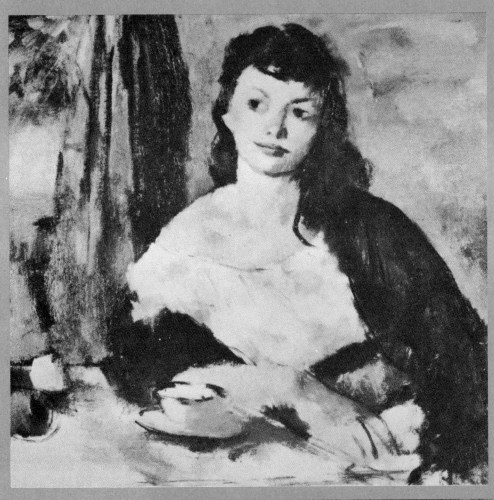

3 The original harsh darks of the eyes have been painted over with middle tones. At this stage the artist is beginning to soften edges, pull the darks together and adjust the nuances of color in the lights.

Up to this point the facial features—eyes, nose and mouth—and the hands, have each been laid in with a minimum number of broad brush strokes. Now it is time for the final steps that will give the painting a properly finished look.

4 More tone is added to the background. These background areas, both light and dark, have been carefully considered. For example, the area of dark to the girl's left was added to vary an uninteresting section and to help balance the dark areas on the opposite side of the picture.

In the finishing process the hands are kept simple but their form and character are clearly defined. Highlights in the eyes, a few dark accents to strengthen the form and sharpen up the features, and the painting is finished.

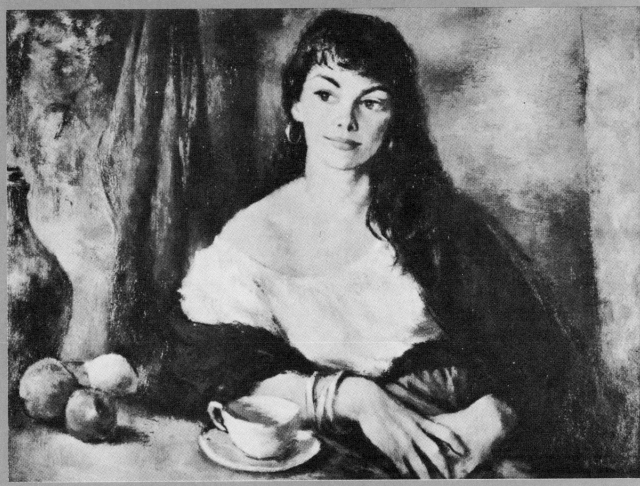

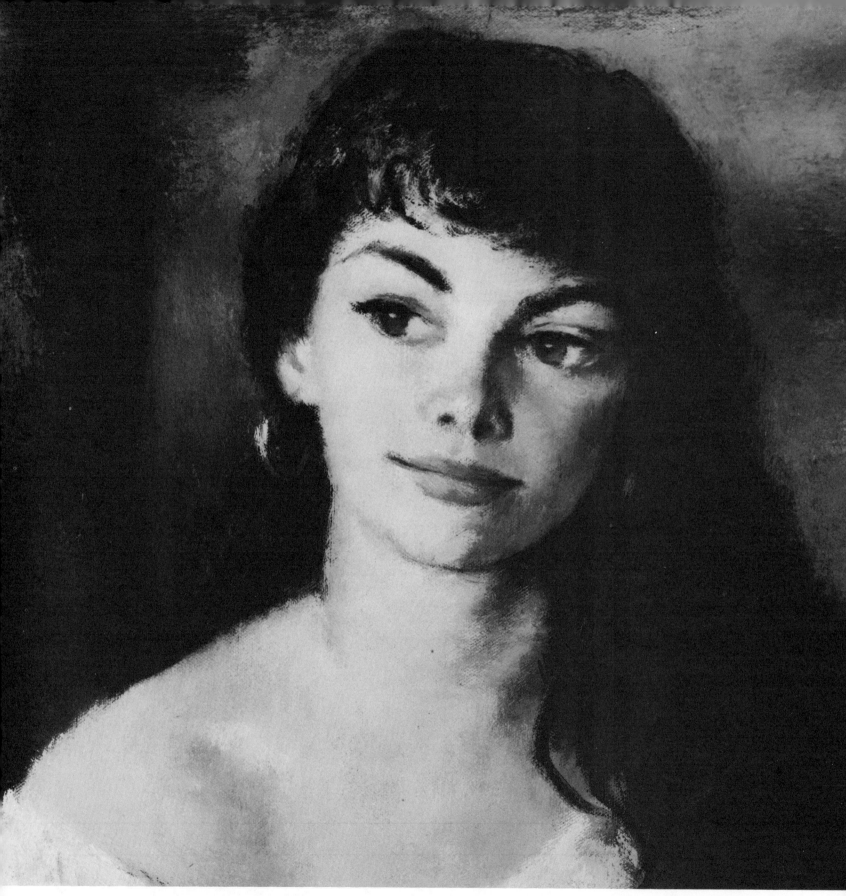

Here is a full-size detail. There are many things you can learn from a careful study of this picture which will help you improve your portraits. Notice particularly the values and the edges. See how simply the light side of the face has been handled. If these values were not carefully controlled, they would destroy the sense of form. The values throughout the whole area of the neck, chest, and shoulders are very close. They are soft and diffused to emphasize the fleshy quality of the form. There are no over-worked halftones or highlights of white paint that would make the surface look like wood, metal or china. The edge between the figure and background is equally soft to emphasize the roundness and solidity of the form.

Self Portrait…*a very personal approach*

Not all portraits are literal representations of the subject. An imaginative artist can evoke personality and appearance by suggestion, inference and symbols.

The following demonstration is an example of one such approach. The artist is Ann Toulmin-Rothe, who explains in her own words the thinking, and the painting procedure, that resulted in the uniquely individual self-portrait you see completed on page 51.

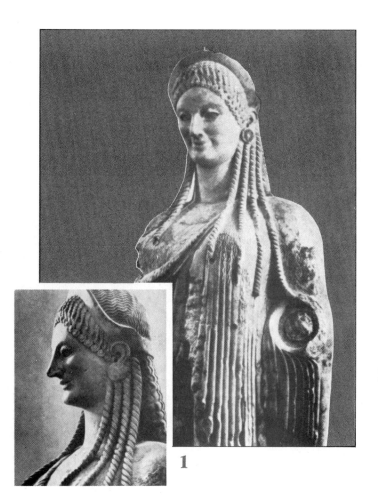

1

2

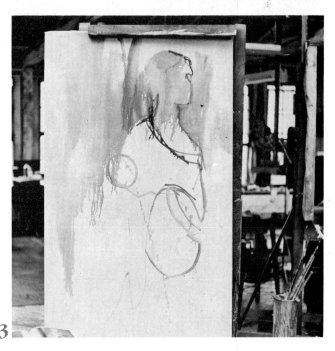

3

1. As I am an artist it's natural to relate myself to a symbol pertaining to the tradition of art. What comes immediately to mind is the Greek culture and certain archaic statues that I can enthusiastically identify with.

2. I draw directly on the white canvas with umber and a small bristle brush. Then I begin to apply thin washes of color liberally mixed with turpentine—a warm tone of burnt sienna for the face and a harmonizing cadmium orange in the background.

3. The three quarter length figure is deliberately placed off center to give the feeling of movement I get from the Greek statue.

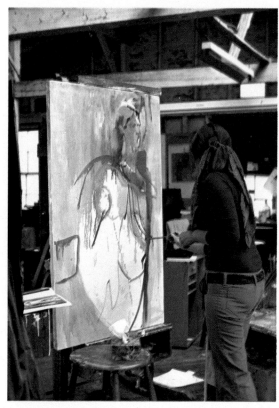 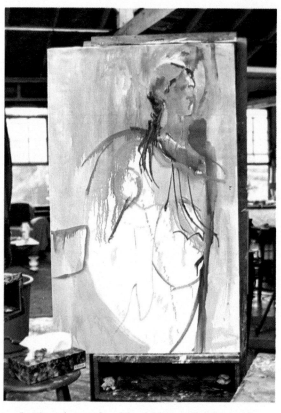

4 Working with big brushes, I establish the principal light and dark shapes and major color areas. I keep working over the entire canvas, not stopping to develop any one part.

5 Letting the washes bleed into each other softens edges and makes the neutral transitionary passages between shapes and colors.

6 I feel that by means of colors and values I'm actually molding the form, pushing back one area and pulling out another. Not until I've worked out all the problems of composing and painting the entire canvas do I give close attention to the particular problems of "likeness."

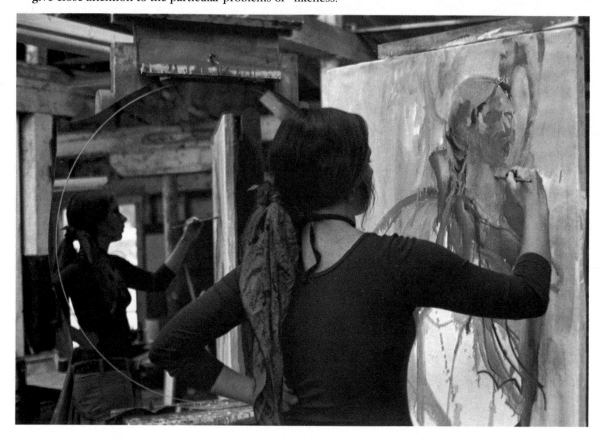

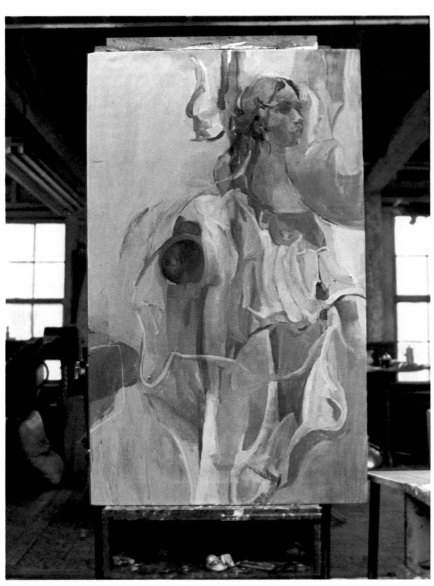

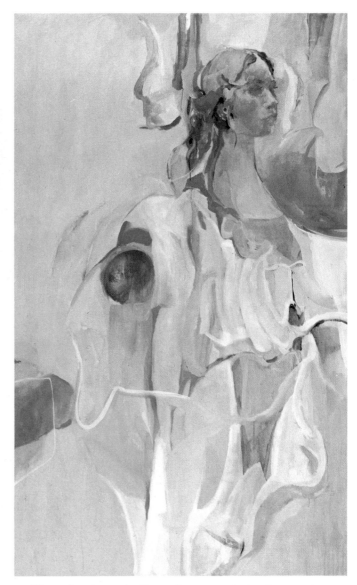

7 A painting is something that grows. I have no formulas. Each problem is different and I go about solving it in a different way.

8 When the picture is all together as a painting I am ready to concentrate on the details of the features, refining and finishing the likeness. The painting is then complete.

Oil color demonstration by *Ann Toulmin-Rothe* on pages 49-51 reproduced by permission of North Light Publishers from *6 Artists Paint A Portrait* © 1974 by Fletcher Art Services, Inc.

Practice Project

With this photograph as a model, it's possible to practice all the subjects we've covered. Look at it closely before you begin. Study the lighting, the shapes and values, the gesture and expression.

Pencil portrait.

Work with a soft pencil directly on the accompanying outline drawing. When you've finished, turn to the Instructor Overlay, page 87, for comparison and suggestions.

Portrait painting.

Use whatever paints or pastels you have on hand to do a portrait in color. If you need help getting started, transfer the outline drawing on page 88 to an appropriate surface, using the method shown on page 80.

Photo by Harry Garfield
Famous Photographers School

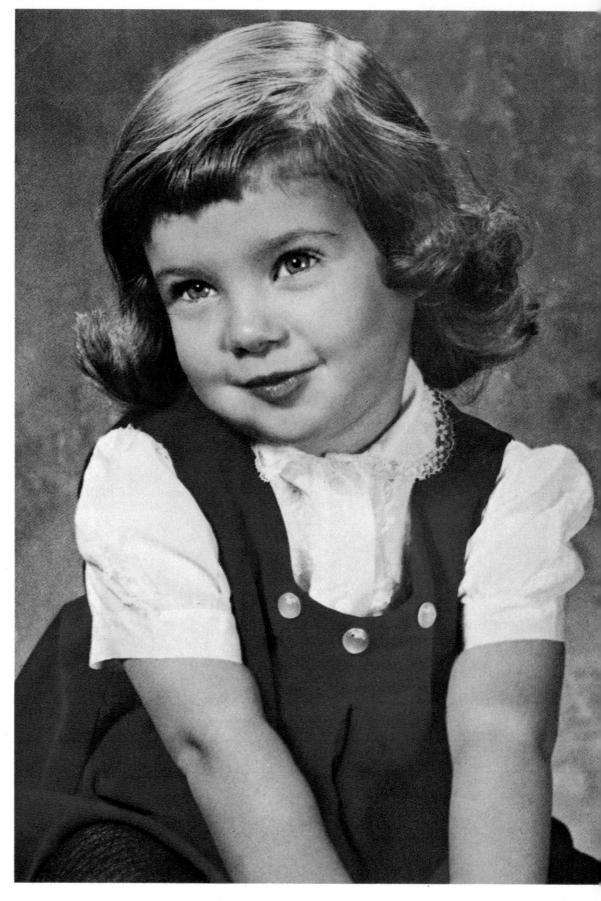

52

Please Note: You can draw on this page with pencil, charcoal or pastel, but *do not paint on it*, as that would damage your book.

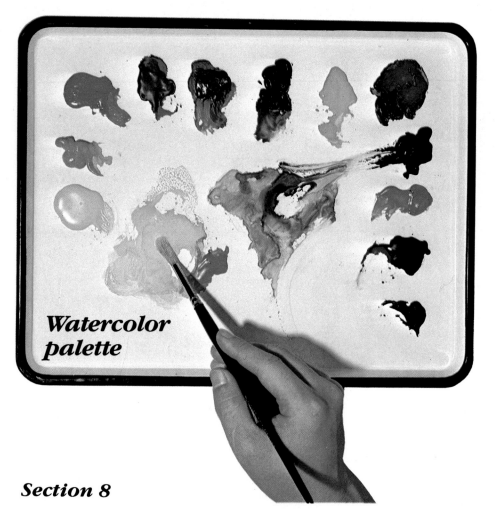

Watercolor palette

How to lay out your watercolor palette

There are many styles of watercolor palettes available but a simple white porcelain-coated butcher's tray makes an ideal mixing surface. Arrange your pigments like this—reading clockwise, they are:

 Cadmium yellow pale
 Raw sienna
 Cadmium red light
 Alizarin crimson
 Burnt sienna
 Raw umber
 Hooker's green
 Thalo green
 Thalo blue
 Cerulean blue
 Payne's gray
 Ivory black

Brushes used for watercolor painting are described on page 34.

Section 8

Watercolor painting

If you've never painted with watercolor you have an adventure ahead of you. It is ideal for making quick, on-the-spot color notes and sketches that can later be made into finished paintings. Its fluid, rapid-drying quality enables you to capture impressions that are fleeting in their beauty. Artists with facility in handling several mediums are warm in their praise of watercolor's flexibility.

Watercolor is clean and fresh. It's a medium to play with—to explore and discover with. You will have "happy accidents" with it that will be most satisfying. Sometimes your "quickies" will be the best of all—especially if you planned well in advance. No two experiences with watercolor are alike.

Watercolor is economical to use. The pigments are so intense in color that a little goes a long way when diluted with water. Also, the painting surfaces you normally use are less expensive than those required for oil paint.

We may give you the impression that transparent watercolor must only be used quickly. This is not intended. You can paint as deliberately as you like. But best results usually come from first planning your painting, sketching it in, and painting it—all in one continuous operation.

Some say watercolor is the most difficult of all mediums to master. This is no more true than to say that tennis is harder to learn than golf. To become proficient in any sport or any kind of painting, you must first master the tools of the trade. You must learn all the nuances, tricks, and techniques the scope of the medium allows. In the following pages, we will get you off to a good start.

Don't confuse *transparent watercolor* with *opaque watercolor* just because both are mixed with water. With *transparent*, the white paper—showing through—makes your light tones. With *opaque*, light tones and whites are made with white pigment. Your transparent watercolor palette contains no white.

First, we will familiarize you with the materials you use in transparent watercolor painting. Then we'll show you how a professional artist makes a painting.

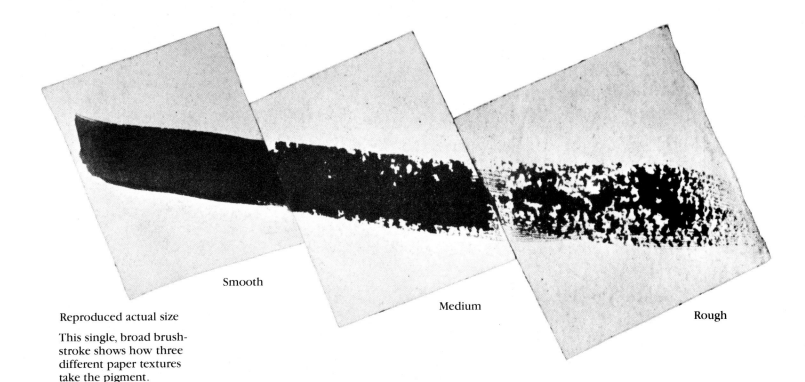

Smooth

Medium

Rough

Reproduced actual size

This single, broad brush-stroke shows how three different paper textures take the pigment.

Watercolor paper

Speaking generally, watercolor papers come in three textures: smooth, medium and rough; and in three degrees or thickness of weight: thin, medium and thick.

The thicker the paper, the less the surface will wrinkle when dry—except when "wet-mounted," which we explain below. To paint a large picture, use the heavy or thick type, because large-size thin paper buckles awkwardly when wet and dries with a wavy surface. For smaller pictures, the medium type is satisfactory. Use thin paper only for practice and the smallest of pictures.

The medium and thin papers may be wet-mounted to make them smooth when finished and dry—even with fairly large pictures. To mount paper this way, wet both sides thoroughly and lay it flat on a wet wooden drawing board—leaving an inch or more of board area showing around the wet paper. When the edges begin to wrinkle, press down with your hand and fasten all four edges to the board with "shipping tape." (This comes in rolls with one side covered with water glue; it is used to seal packages for shipping.) When your painting is finished and dry, trim it around the edges with a razor blade to free it from the board. No need to wet-mount the heavier papers. Dry-mounting is sufficient. This is easy. Simply fasten your paper to the board with thumbtacks or masking tape all around the edges.

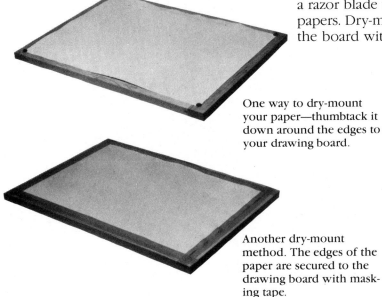

Watercolor pad. Inexpensive and practical for outdoors and in. Let painting dry, then peel off, as shown.

One way to dry-mount your paper—thumbtack it down around the edges to your drawing board.

Another dry-mount method. The edges of the paper are secured to the drawing board with masking tape.

Close-up technique of fastening edges of the paper to the drawing board with shipping tape.

55

How to use color with water... methods and techniques

The tonal values in a watercolor are determined by the degree to which the white paper shows through the washes of paint. This, in turn, depends on the amount of water used in the brushes. A very wet brush will result in light tonal values. Less water will produce medium tones. Pure pigment with very little water, allowing none of the paper to show, will give the heaviest darks.

As you practice and learn you will be able to get many and varied effects by applying your brush filled with these different water and pigment mixtures. On this page are demonstrated a number of the more useful combinations you can get by using your brush from very wet to dry. A medium sized brush and a dark pigment were used in making these examples.

Watercolor brushes

No. 9 **round**

¾-inch **flat (single stroke)**

Your most useful brush will probably be the round shape. Rounds range in size from #4 to #14, the largest. The #9 is the most needed, but you might also want #4, #7, and #14 for a good range of sizes. Use large brushes for large areas, small ones for small areas, details, fine lines.

Three popular sizes of flat single-stroke brushes are the ½-inch, ¾-inch, and 1-inch. You might start painting with the middle size, then add others as needed.

Red sable brushes are the best. After use, clean them thoroughly in soap and warm water, but don't wash out all the soap. This keeps the hairs pliable.

Dry brush.
This stroke is made by drawing the brush—holding very little water and plenty of pigment—quickly across dry paper. Observe the flaky texture created.

Wet-in-wet.
A very wet brush, with pigment on very wet paper, gives us the above feathered-out blended-edge area.

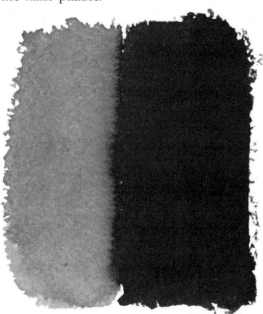

Blended edge.
To make the edges of two wet colors blend, paint one quite wet, then place the other, less wet color so their edges touch. Color from the second stroke will blend into the first.

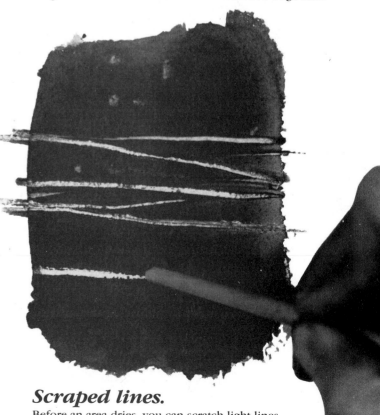

Scraped lines.
Before an area dries, you can scratch light lines through it with the butt end of your brush.

56

How to Paint a Portrait in Watercolor

From the preceding remarks on the nature of watercolor, you can see that painting a portrait in this medium is a different matter from painting one in oil. Because it calls for spontaneous execution it lends itself to quickly recording the immediate gesture, to catching a vivid glimpse of a person rather than a detailed likeness.

The paintings of Charles Reid, whether in oil or watercolor, sparkle with the presence of light. With this interest in light, and a facility for working quickly and spontaneously, he particularly favors watercolor for capturing the gesture and mood that is sometimes lost in more formal oil portraits.

Here is how Charles Reid paints a portrait in watercolor.

I like to find a pose that doesn't look deliberately arranged. This is one of the advantages of watercolor—you can capture the subject at an odd moment, in a natural gesture. ·

1 Before beginning to paint I believe it's important to do as accurate a drawing as possible. Keep the pencil lines light because they are going to show through your painting in some areas.

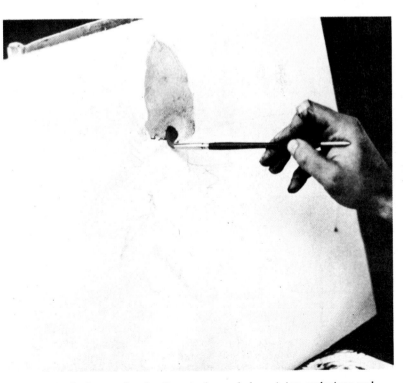

2 A light flesh tone for the first wash, made by mixing cadmium red light with yellow ochre and adding a little cerulean blue for the cooler areas. Always work from light to dark—and remember that washes dry lighter than they look when they're wet.

Keeping the portrait fresh...large shapes first, details last.

That's the secret! In doing this portrait the artist could apply his watercolor washes boldly and directly because he planned the drawing accurately before touching the paper with his brush. That type of planning, together with thoughtful observation and careful control of the wetness of each brush stroke enabled him to paint with confidence.

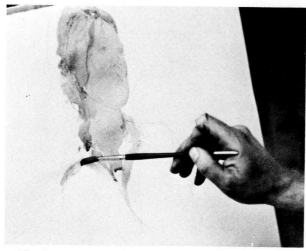

3 The first wash can be used to cover practically the entire drawing—hair and blouse as well as the face. Once I've begun a wash I don't work back into it to make corrections, Don't worry about a few drips. Most of them will be covered by successive washes.

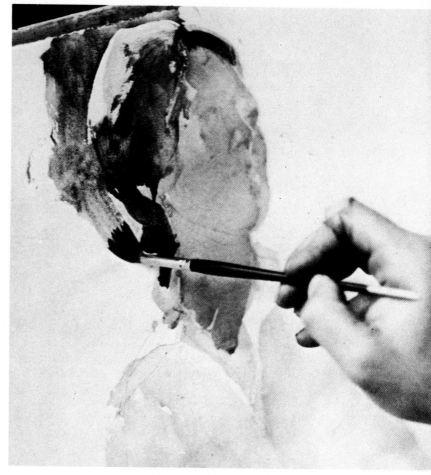

5 By using the second wash to define the shadow shapes I build form and give the head three dimensional solidity. Reflected lights in the shadows are lifted out with clean, wet (but not too wet) brush.

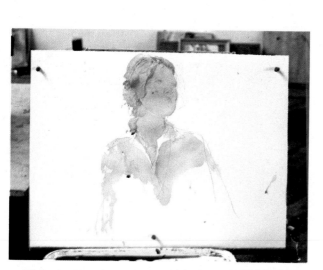

4 To make the second wash darker than the first I substitute raw sienna for yellow ochre in the color mixture and use less water. You can make as many over-washes as you need to build a solid structure, but don't let the painting get too dark and heavy.

Watercolor demonstration by *Charles Reid* on pages 57-61 reproduced by permission of North Light Publishers from *6 Artists Paint A Portrait* © 1974 by Fletcher Art Services, Inc.

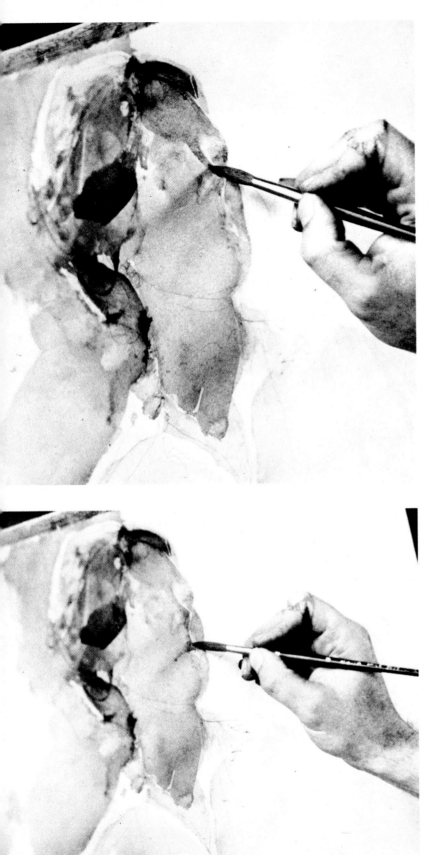

Each time I dip my brush in the water I give it a shake to get rid of the excess moisture. Then I dip into the paint on the palette. The brush should be wet but not too watery. The paint must flow onto the paper. It takes practice.

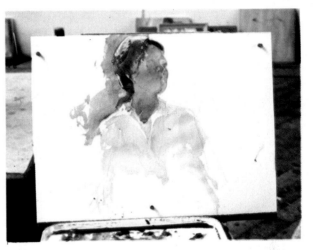

7 Only when the structure of the head has been firmly established do I turn my attention to the facial features.

8 It's better to suggest the features than to try to delineate them in detail. I keep the value fairly light when I paint eyes, eyebrows and mouth, then accent the darkest darks with wet dropped into wet.

59

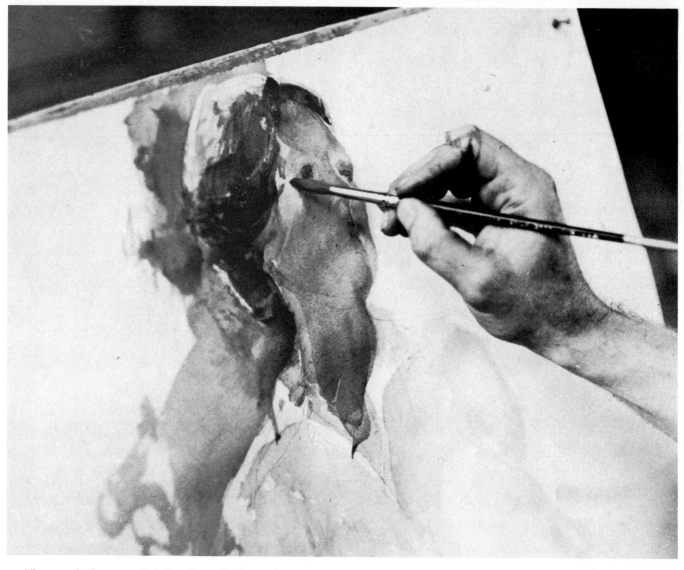

9 The mouth, for example, is hardly really there. I look for the darkest dark in each area. The corner of the mouth on the right side seemed to be the darkest spot. So I hit it hard. I tried to get the feeling of the mouth without entirely painting it in.

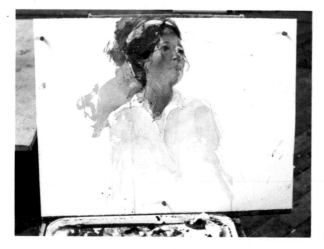

10 Keep in mind that you're not copying so much as you are interpreting the model. What seems to work best in terms of shapes, values and colors that you put on the paper is, finally, more important than what you actually see in front of you while you're painting.

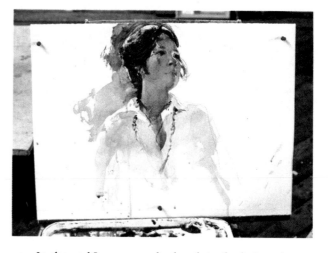

11 In the end I use some dry brush in the hair and a razor blade to pick out the highlights. Knowing what to leave out and when to stop is important in painting a watercolor.

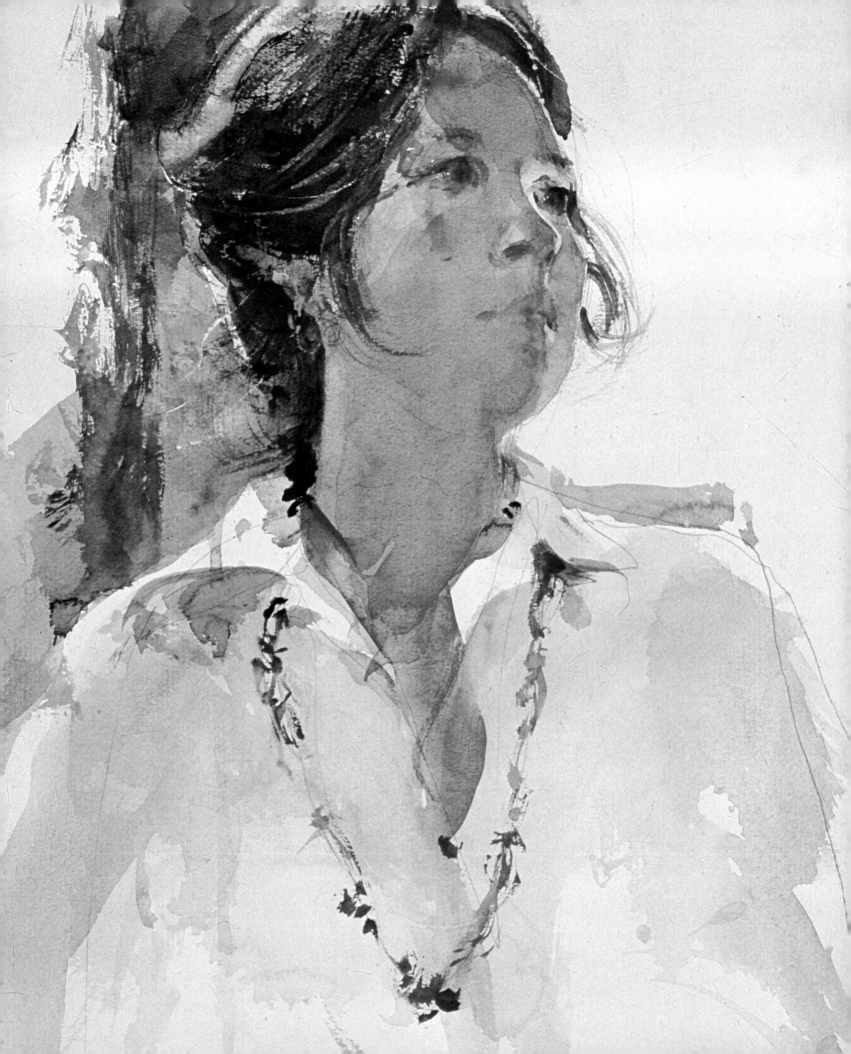

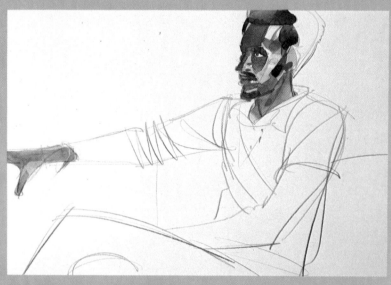

With sweeping pencil strokes the artist indicates the gesture of the pose and the dominant rhythms of the clothing. A few simple areas of color establish the planes of the head.

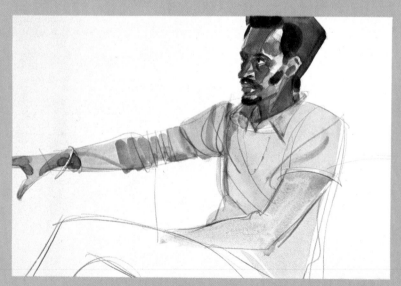

Because the shapes are so well designed, the color areas in the clothing can be almost flat. This keeps the viewer's eye focused on the face.

. . . a fresh, spontaneous approach

This sketch combines keen observation with spontaneous but disciplined control of watercolor techniques. Every line, shape, value and color area counts, and contributes to the total effect. However, it is not merely a technical tour de force. Instead, it is a sensitive artist's response to the sitter—capturing both a fleeting impression and a timeless mood quality with sure, decisive strokes of pencil and brush.

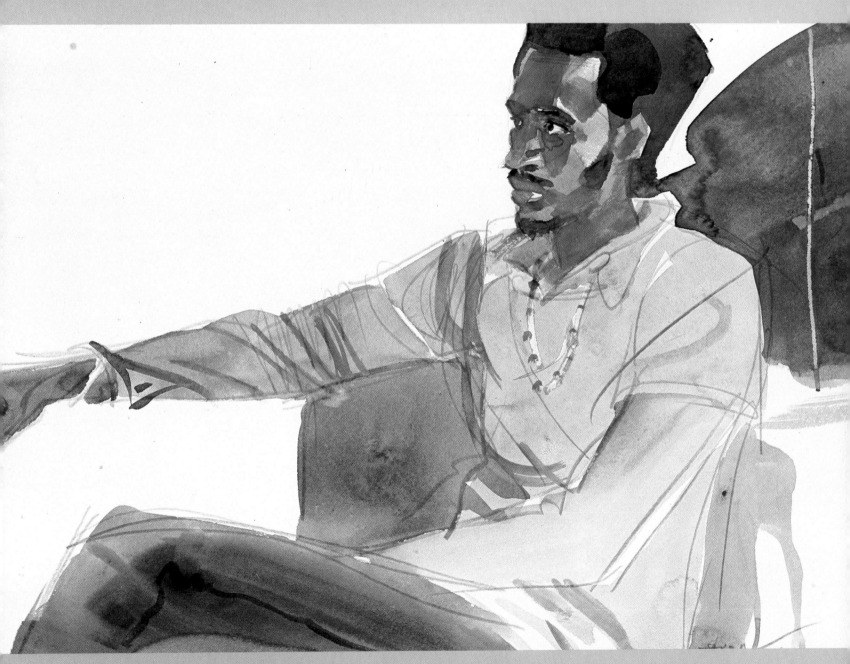

Here's the finished sketch. The sharpest contrasts of values and shapes are kept in and around the head, especially in the eye. Details of clothing have been kept to a minimum, but we have the feeling that everything is in place.

Watercolor demonstration on pages 62-64 by *Norito Saimaru, Instructor* at Kodansha Famous Schools, Inc., Tokyo, Japan.

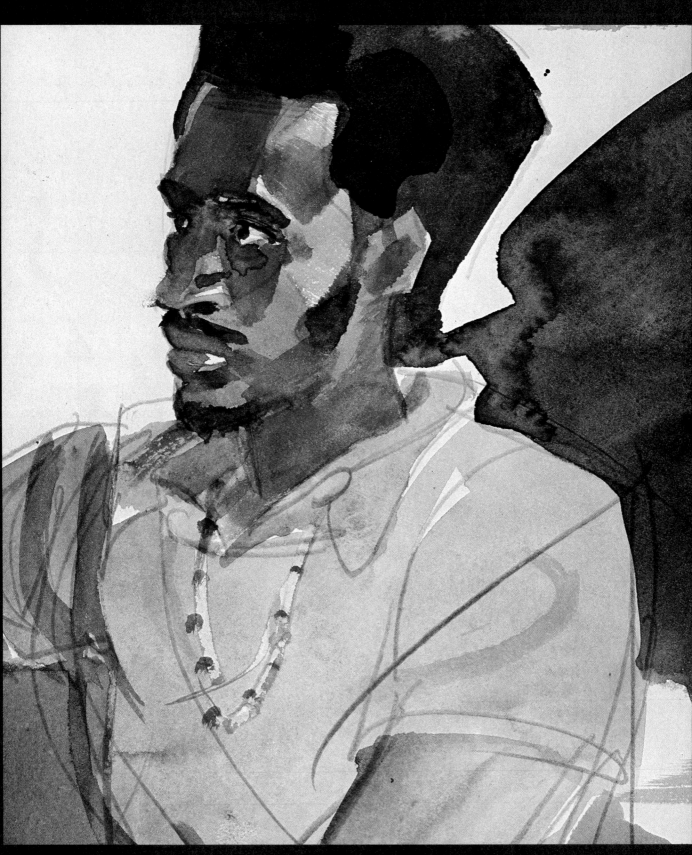

This detail of the painting, reproduced at the same size as the original, gives you an opportunity to study the effect of each stroke of the artist's brush. You will find it helpful to turn the picture upside down or sideways. That way you can see the separate shapes and overlapping strokes more clearly.

Practice Project

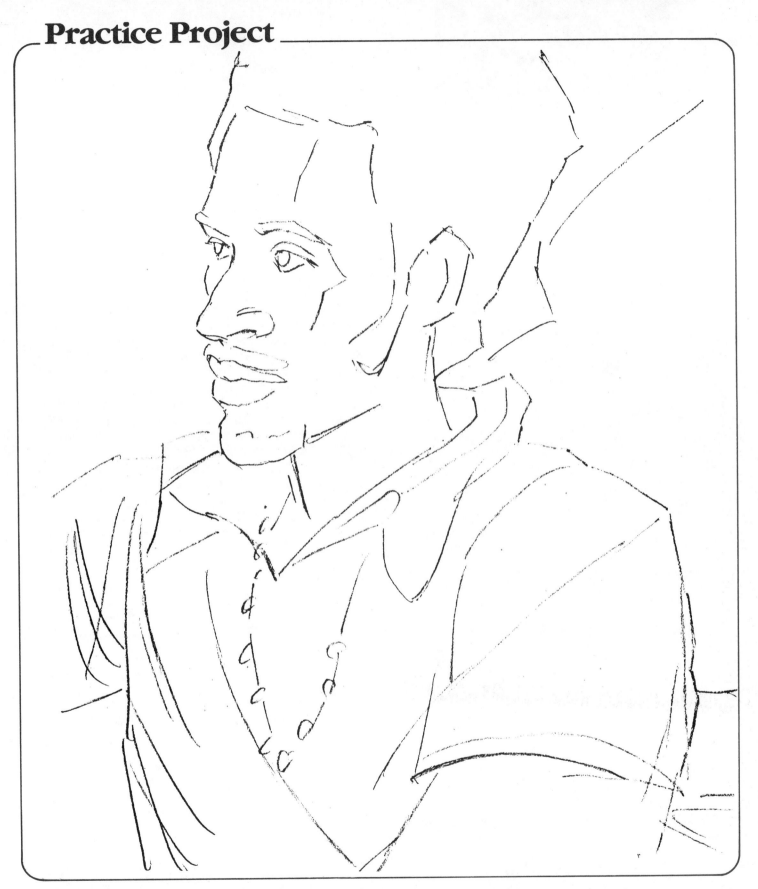

For practice, do a pencil drawing of this head directly on this page. Make strokes with the side of a soft pencil. If you wish to do a painting, transfer the outline drawing on page 89 onto watercolor paper using the method shown on page 80.

Please Note: You can draw on this page with pencil, charcoal or pastel, but *do not paint on it*, as that would damage your book.

A natural pose is nearly always best. Don't try to force a young person into your preconceived idea of what the pose should be.

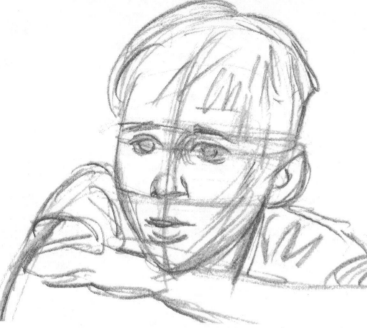

Look for the gesture and individual characteristic expressions. Then construct your drawing with an eye to correct proportions.

Section 9
Childhood...
how to capture it

Portraits of children have wide appeal. The best are often animated by lively expression—a smile, a laugh, a look of wonder, sadness, surprise or delight. Capture these fleeting moments and you have produced something that parents will cherish.

Many artists who specialize in children's portraits paint one or more color sketches and then take a number of photographs. A Polaroid camera is particularly useful because it will give you instant prints while you are experimenting with the pose.

The best way to find the right pose is to let the child behave naturally. Often a picture book, stuffed animal or other toy will help solve the problem. Children behave differently at different ages so you must adjust your approach to the age of your model.

Practice Project

You can make a pencil drawing of the child directly on the facing page. Also, if you wish to do a painting and need help getting started, trace the outline and transfer it using the method shown on page 80.

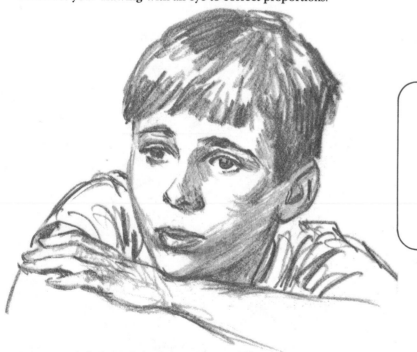

Use a simple light and shadow pattern and keep the details simple. The younger a child is the smoother and simpler the shades.

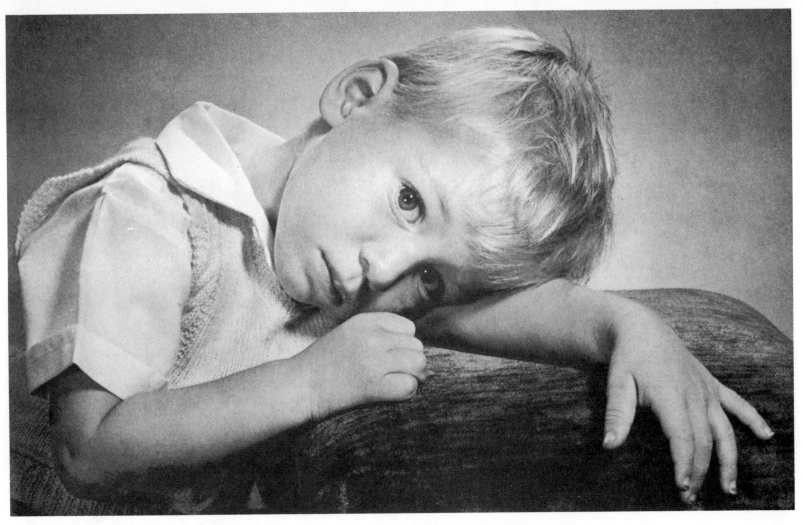

Please Note: You can draw on this page with pencil, charcoal or pastel, but *do not paint on it*, as that would damage your book.

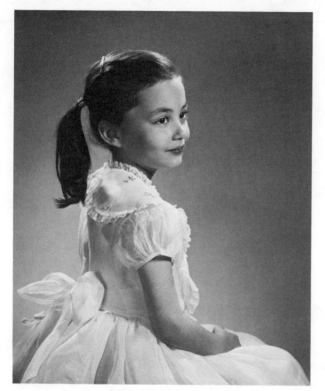

Practice Project...
girl with black pony-tail

Look for the unique and interesting features that individualize the model, such as this girl's pony-tail. By posing her at a three-quarter angle we have shown this important feature to best advantage.

You can draw directly on the facing page, using a soft pencil. If you wish to do a painting, trace the outlines and transfer them onto an appropriate surface, using the method explained on page 80. The tracing paper overlay, page 90, shows how an instructor interpreted this pose.

Things to remember:

- **Gesture**
 Note the definite "S" curve of the pony-tail and the rhythm suggested by the alternating curves of the back and face.

- **Construction**
 Think of the solid egg shape of the head and the cylindrical forms of the body, neck and arms.

- **Pattern**
 Plan the principal shapes in a simple value pattern of black, two grays and white. (Review pages 40 and 41.)

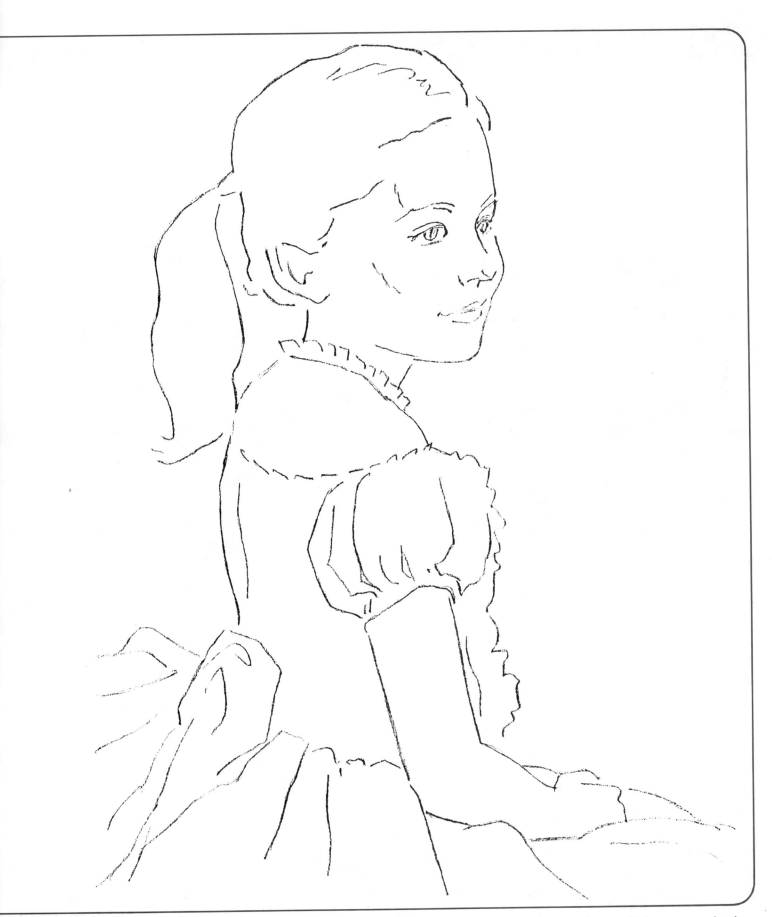

Please Note: You can draw on this page with pencil, charcoal or pastel, but *do not paint on it*, as that would damage your book.

This subject is ideal—having well-defined areas of light and shadow.

How to Draw with Light

Attractive portraits can be created on tinted charcoal paper, using white or light pastels for highlight areas and details. The dark lines and tones can be made with charcoal, carbon or conte pencils—or you can use colored pastels. Portraits done this way can achieve most pleasing effects with a minimum of effort. Framed, they make welcome presents—or you may find a ready market for them.

You can start your drawing directly on the tinted paper or do a preliminary drawing on tracing paper and transfer the simple outlines onto the tinted paper.

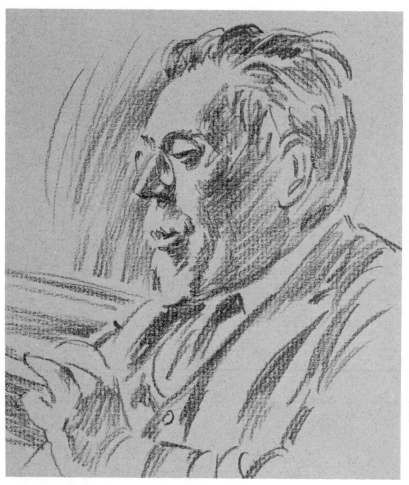

The dark areas are developed with a charcoal or carbon pencil. A loose, sketchy effect is appropriate and pleasing.

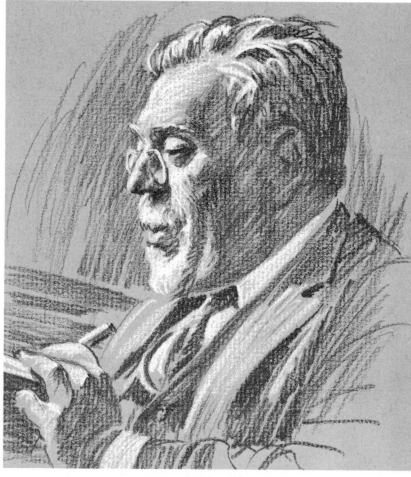

Highlight areas are added, using white chalk or pastel. Don't overdo this, however, or you'll lose the fresh, spontaneous look.

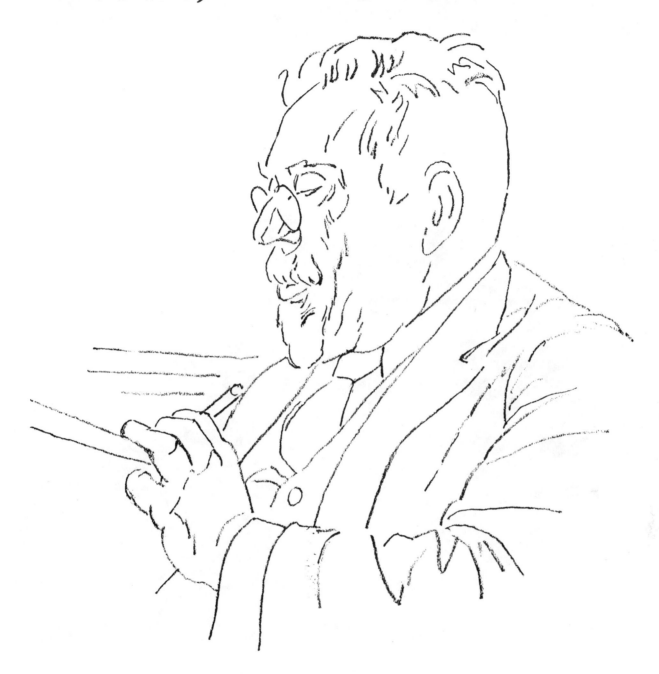

As a practice exercise complete the drawing on this page, using a soft pencil or charcoal. (It's not necessary to completely fill in the background.) This will familiarize you with the shapes, forms and lighting and so prepare you to do a similar drawing on gray paper, using the method shown on the facing page.

For your final drawing, tinted charcoal paper is recommended, but almost any toned paper will do—even shirt cardboard. If you need help you can trace the outlines and transfer them onto any gray paper or board, using the method shown on page 80.

Please Note: You can draw on this page with pencil, charcoal or pastel, but *do not paint on it*, as that would damage your book.

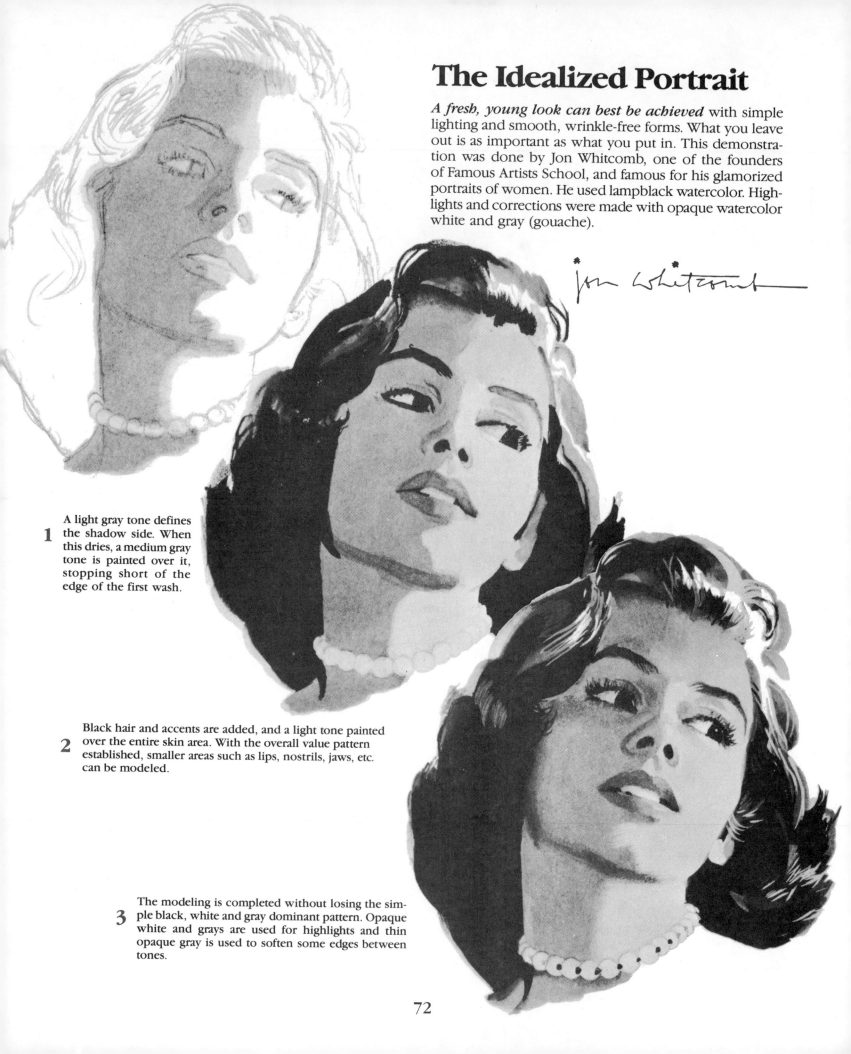

The Idealized Portrait

A fresh, young look can best be achieved with simple lighting and smooth, wrinkle-free forms. What you leave out is as important as what you put in. This demonstration was done by Jon Whitcomb, one of the founders of Famous Artists School, and famous for his glamorized portraits of women. He used lampblack watercolor. Highlights and corrections were made with opaque watercolor white and gray (gouache).

jon Whitcomb

1 A light gray tone defines the shadow side. When this dries, a medium gray tone is painted over it, stopping short of the edge of the first wash.

2 Black hair and accents are added, and a light tone painted over the entire skin area. With the overall value pattern established, smaller areas such as lips, nostrils, jaws, etc. can be modeled.

3 The modeling is completed without losing the simple black, white and gray dominant pattern. Opaque white and grays are used for highlights and thin opaque gray is used to soften some edges between tones.

Practice Project...*idealized portrait*

Complete this drawing in pencil or charcoal, establishing and controlling your value pattern as Jon Whitcomb did in his demonstration. This will give you confidence as you paint this or any other head.

If you wish to do a painting, you can trace the outlines and transfer them onto an appropriate surface, using the method explained on page 80.

Please Note: You can draw on this page with pencil, charcoal or pastel, but *do not paint on it,* as that would damage your book.

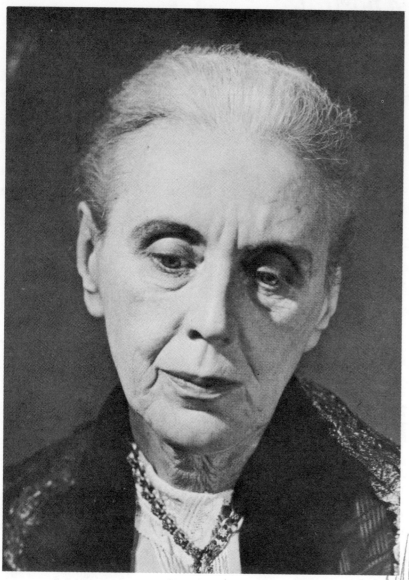

Capturing Beauty in an Older Person

Photographs often accentuate the less attractive features of older people while failing to show their charms to best advantage. The portrait painter, on the other hand, is able to put the emphasis on beauty, tenderness, dignity and all the finer attributes that are so frequently to be seen in mature faces. Naturally we don't want to ignore all signs of age or the portrait would be unreal and lacking in character. But it's possible to soften harsh wrinkles and sagging skin folds to achieve just the right balance.

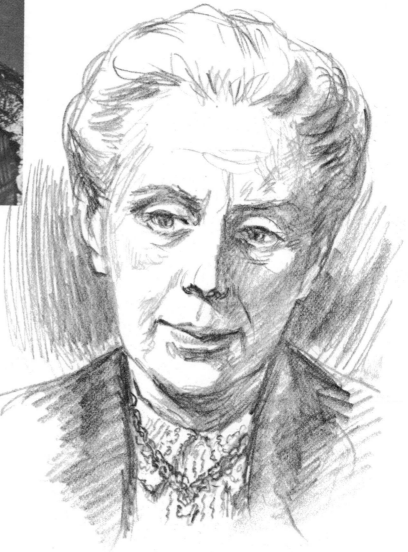

Helpful Hints

Some points may apply, others not, but consider them before doing a portrait of an older person.

Wrinkles. Soften and simplify.

Eyes. Open slightly if lids tend to droop.

Eyebrows. Can be slightly raised to give animation.

Ears. Make a bit smaller and let hair partially cover them

Neck. Use shadow under jaw to make sagging less noticeable.

Clothing. If necessary adjust for neater appearance.

Accessories. Take advantage of ornamental details such as a necklace, lace collar, or colorful shawl.

Practice Project

Complete this drawing in pencil or charcoal. Draw either on this page or
on another sheet of paper.

If you wish to do a painting, you can trace the outlines and transfer them
onto an appropriate surface, using the method explained on page 80.

Please Note: You can draw on this page with pencil, charcoal or pastel, but *do not paint on it*, as that would damage your book.

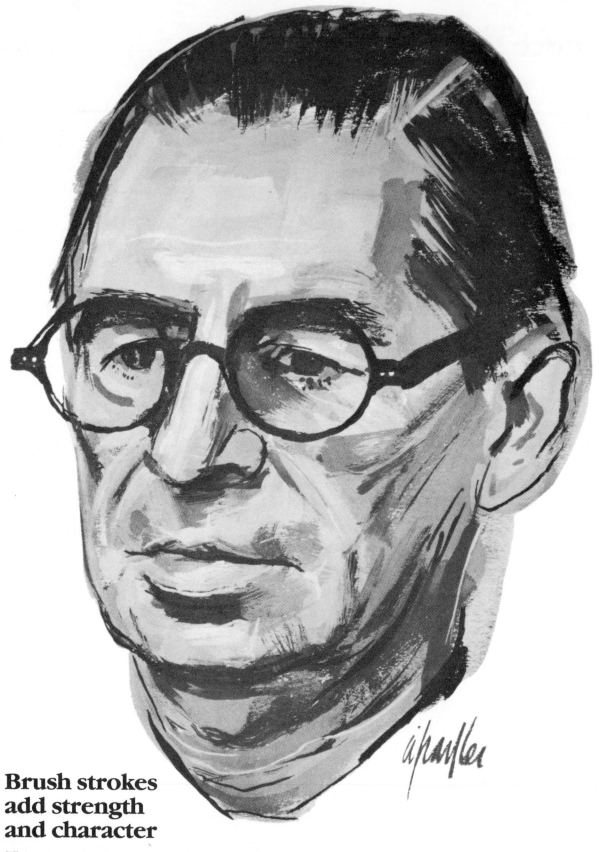

Brush strokes add strength and character

This strong portrait was painted in opaque black, white and gray watercolors (gouache) by Al Parker, a versatile artist and one of the founders of Famous Artists School. It is freely painted, with all the assurance that a trained eye and thorough knowledge of structure command. Here is an example where bold brush strokes add interest and vitality to a male portrait. In this instance a smooth, "photographic" treatment would be considerably less effective.

Practice Project... *using a bold technique*

Here is a chance to demonstrate for yourself the powerful effect you can achieve with bold, free strokes of pencil or brush. First, complete a pencil drawing on this page. Make most of your strokes with a soft pencil, held under the palm of your hand. Use a writing grip only for details.

If you wish to do a painting, you can trace the outlines and transfer them onto an appropriate surface, using the method explained on page 80.

Please Note: You can draw on this page with pencil, charcoal or pastel, but *do not paint on it*, as that would damage your book.

Information shots

After making a color sketch to capture a live impression of the sitter, the artist takes several photographs to refer to when the sitter is not present.

A view from the easel

This artist has also made his color sketch and is taking shots from different angles to reinforce his sense of the three dimensional roundness of the forms.

Section 11

You May Find Photographs Useful

Some portrait artists find photographs helpful. Your use of photography will depend on your own working habits. It may not always be possible to have subjects pose for you as many hours as you would like, particularly when small children are involved. With a camera you can capture actions and expressions that your models could not hold.

The camera can record for you to select from but it can't do your job for you. Don't make the mistake of thinking that tracing a photograph is a substitute for creative drawing and painting.

Simple equipment is all you need

Whatever type of camera is available to you can be sufficient. Whether you use a reflex camera, a Polaroid which conveniently produces pictures in seconds, or any other kind, the important thing is light. Shooting out-of-doors when the light falls on your subject just as you wish to paint it is a simple solution. You will find, however, that you can control your lights and shadows better indoors using artificial lights. Two or three reflector-type bulbs or photo-flood bulbs in metal reflectors can be arranged to light your model in whatever way you want.

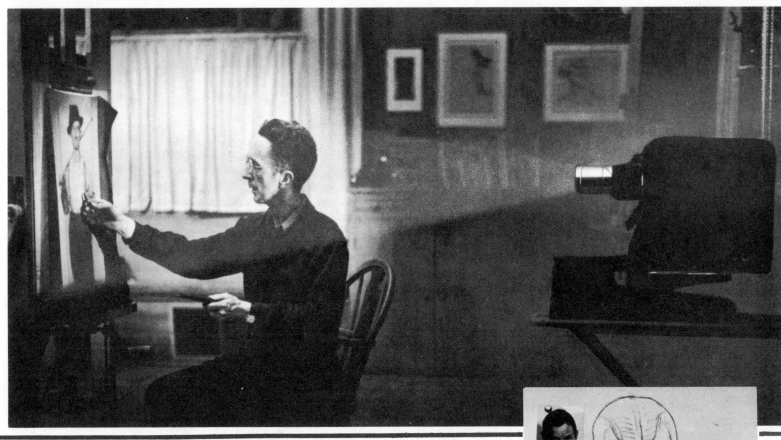

How to use a projector

A projector is a convenient and time-saving device for making a picture larger or smaller. The material to be enlarged or reduced is simply positioned in the machine, which projects an image through a lens onto the paper or whatever material is to receive the transfer. When the image has been adjusted to the desired size, the drawing is made over it.

It isn't necessary to copy the image exactly as projected. Creative changes can be made in the process, thereby retaining the freshness of the original and possibly making improvements.

The Balopticon that Famous Artist School founder Norman Rockwell is using in the above picture is an expensive model, but many artists get good results with very reasonably priced projectors.

A transparency projector can be used for color slides and black and white positive transparencies.

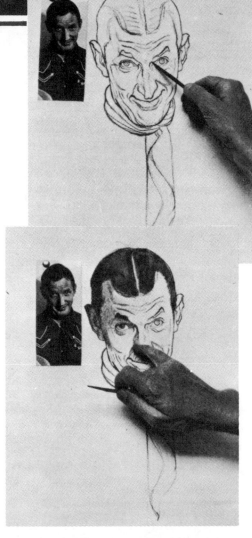

The drawings at the right show two steps of a charcoal portrait by Norman Rockwell. He used the projected image merely as a starting point, and made many, many subtle changes, sharpening the characteristics he wished to emphasize. Working this way, the skill and taste that you use in making such changes will insure that the finished picture will be distinctively your own. Always keep in mind Mr. Rockwell's advice: "Never just thoughtlessly copy the projection of a photograph."

79

Think with Tracing Paper

The beauty of using tracing paper is that it allows you to first make a preliminary trial drawing; then, because it's transparent, you can slip it under a clean sheet and proceed to correct and adjust as you redo the drawing.

You can repeat this as many times as it takes. Be sure, however, that you *don't just mindlessly trace.* Make each successive drawing an improvement, and strive for spontaneity in every new version.

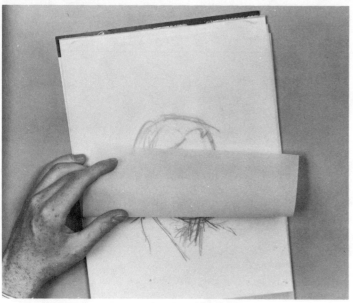

1 *New sheet:* Fasten a sheet of tracing paper over your sketch and do a new drawing, using your previous one as a guide and making the necessary improvements.

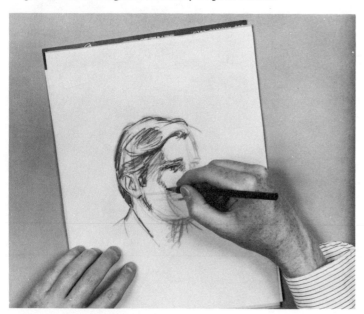

2 *Refining your drawing:* If your drawing needs further adjustments, place a clean sheet of tracing paper over it and continue developing it to the degree of finish you wish.

Transfer with Tracing Paper

It's easy to transfer the outlines of a drawing onto another surface. First, lay a sheet of tracing paper over the picture you wish to duplicate and, with a medium soft pencil, trace the main outlines. Then follow the steps below. If your original drawing was done on tracing paper, as described to the left, just turn it over, blacken the back of the outlines, and trace it down. This method gives you a clean surface on which to work, free from erasures and smears.

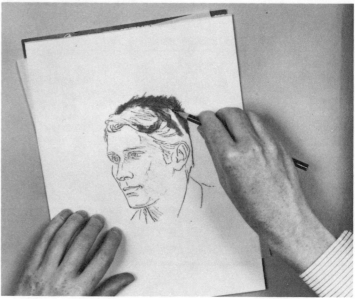

1 *Preparing the back:* Turn your tracing over and blacken the paper right over the back of your traced lines with a soft pencil.

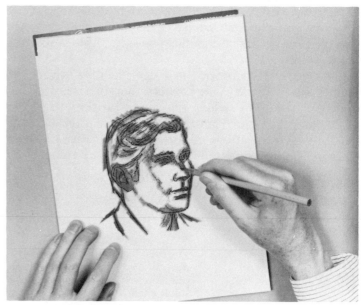

2 *Transferring:* Tape the top corners of your tracing onto the surface on which you plan to draw or paint. With a sharp pencil trace over the outlines and they will be transferred to your drawing surface.

Tracing Papers... *the following pages include these items:*

3 Outline Guides for Practice Projects. You can transfer this onto a surface appropriate for painting, using the transfer method described on page 80.

7 Instructor Overlays. These demonstrations show how instructors at Famous Artists School completed the Practice Projects. Remove them to compare with your own project drawings.

6 Blank sheets of tracing paper. These will give you a chance to try out this useful and popular type of paper. Similar paper is readily available at stores selling art supplies.

FREE ART LESSON. This is the most important project of all. You'll find it at the end of the book. Complete it and mail it to get a free evaluation from the instruction staff of Famous Artists School.

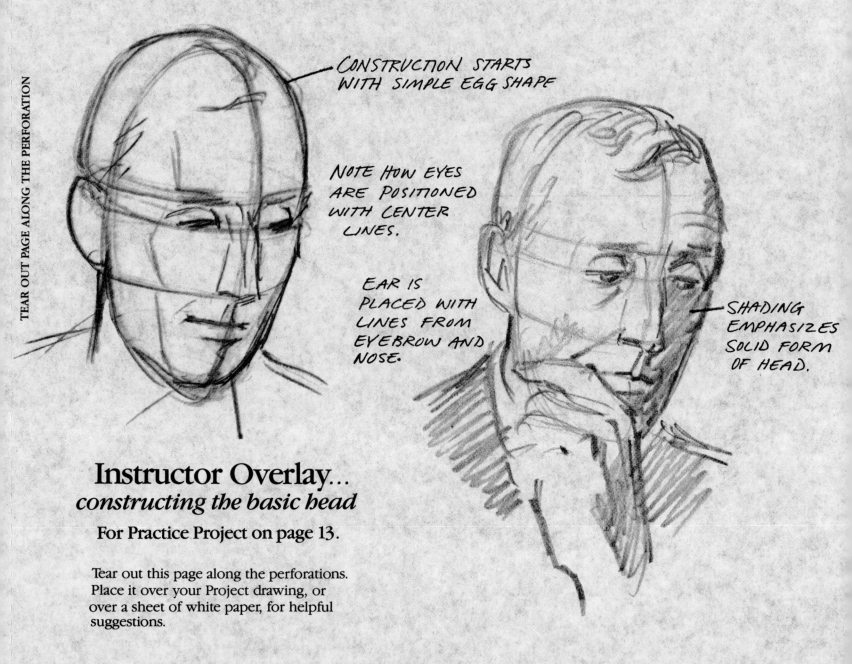

TEAR OUT PAGE ALONG THE PERFORATION

CONSTRUCTION STARTS WITH SIMPLE EGG SHAPE

NOTE HOW EYES ARE POSITIONED WITH CENTER LINES.

EAR IS PLACED WITH LINES FROM EYEBROW AND NOSE.

SHADING EMPHASIZES SOLID FORM OF HEAD.

Instructor Overlay...
constructing the basic head

For Practice Project on page 13.

Tear out this page along the perforations. Place it over your Project drawing, or over a sheet of white paper, for helpful suggestions.

Tracing Papers... the following pages include these items:

3 Outline Guides for Practice Projects. You can transfer this onto a surface appropriate for painting using the transfer method described on page 80.

7 Instructor Overlays. These demonstrations show how instructors at Famous Artists School completed the Practice Projects. Remove them to compare with your own project drawings.

6 Blank sheets of tracing paper. These will give you a chance to try out this useful and popular type of paper. Similar paper is readily available at stores selling art supplies.

FREE ART LESSON. This is the most important project of all. You'll find it at the end of the book. Complete it and mail it to get a free evaluation from the instruction staff of Famous Artists School.

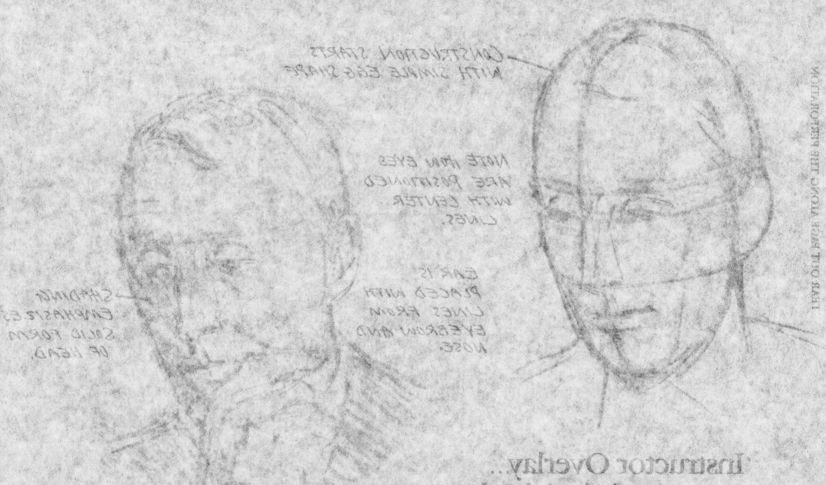

CONSTRUCTION STARTS WITH SIMPLE EGG SHAPE

NOTE HOW EYES ARE POSITIONED WITH CENTER LINES.

EAR IS PLACED WITH LINES FROM EYEBROW AND NOSE.

SHADING EMPHASIZES SOLID FORM OF HEAD.

Instructor Overlay...
constructing the basic head
For Practice Project on page 13.

Tear out this page along the perforations. Place it over your Project drawing, or over a sheet of white paper for helpful suggestions.

Instructor Overlay...*gesture*
For Practice Project on page 16.

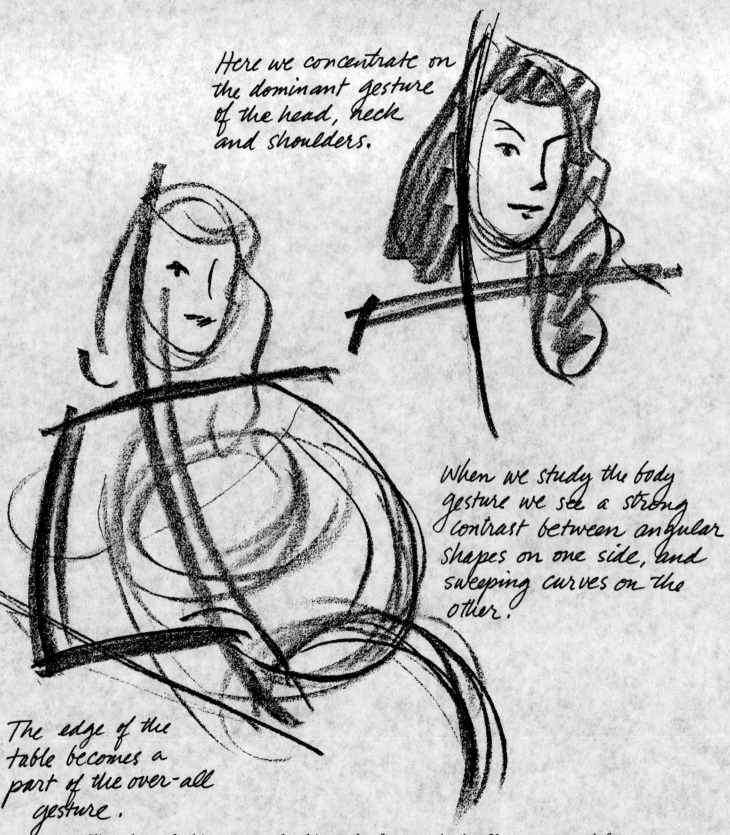

Here we concentrate on the dominant gesture of the head, neck and shoulders.

When we study the body gesture we see a strong contrast between angular shapes on one side, and sweeping curves on the other.

The edge of the table becomes a part of the over-all gesture.

Slip a sheet of white paper under this overlay for easy viewing. You can remove it for comparison with your Practice Project. You'll find these suggestions from an Instructor of the Famous Artists School most helpful.

Here we concentrate on the dominant gesture of the head, neck and shoulders.

When we study the body against, we set a strong contrast between angular shapes on one side, and sweeping curves on the other.

The edge of the table becomes a part of the over-all gesture.

Slip a sheet of white paper under this overlay for easy viewing. You can remove it for comparison with your Practice Project. You'll find these suggestions from an Instructor of the Famous Artists School most helpful.

82

Outline Guide...*portrait painting*
For Practice Project on page 33.

TEAR OUT PAGE ALONG THE PERFORATION

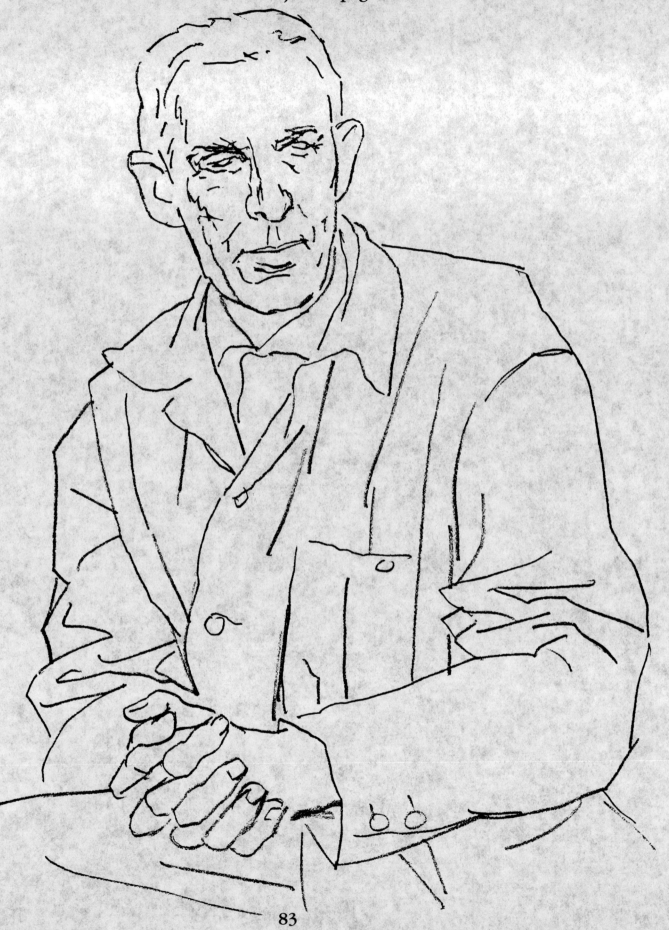

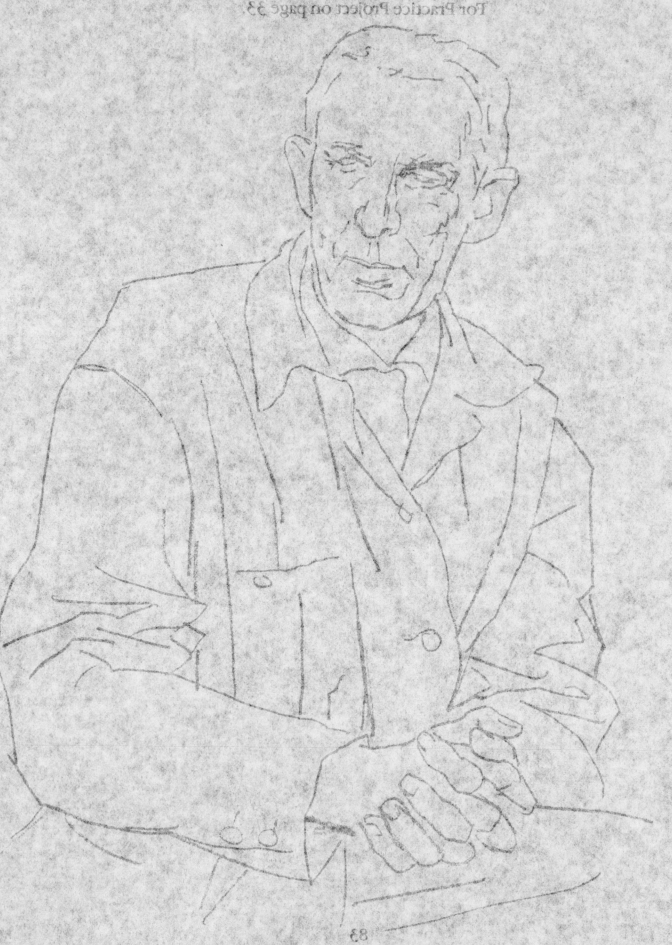

Instructor Overlay...*pencil portrait*
For Practice Project on page 33.

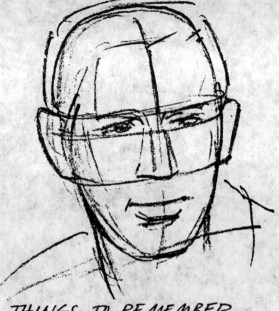

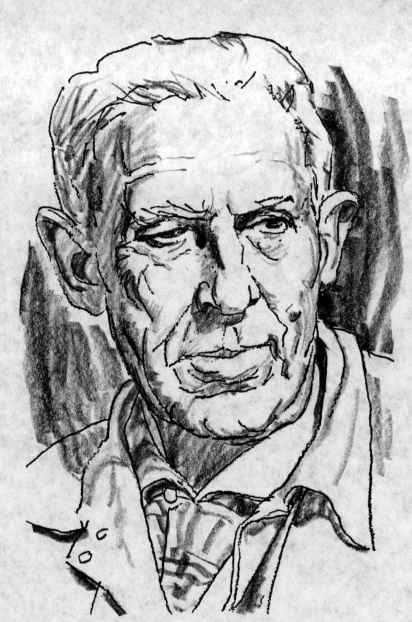

THINGS TO REMEMBER
- *Basic egg shape for head*
- *Center line, in front, places features*
- *Lines from brows and bottom of nose locate ears.*

If you keep in mind the points listed at the right, you can control a portrait drawing... even though it is highly detailed and textured.

Simple light and shadow pattern... before details

Slip a sheet of white paper under this overlay for easy viewing. You can also remove it and place it over your Practice Project for comparison and helpful suggestions from an Instructor of the Famous Artists School.

84

Slip a sheet of white paper under this overlay for easy viewing. You can also remove it and
place it over your Practice Project for comparison and helpful suggestions from an instructor
of the Famous Artists School.

84

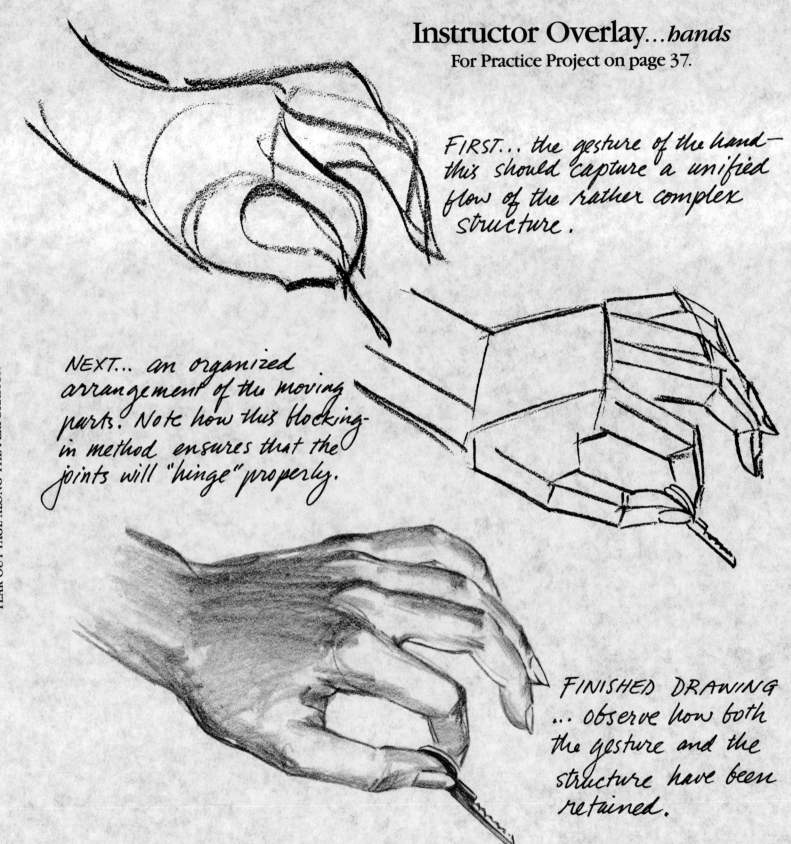

Instructor Overlay...*hands*

For Practice Project on page 37.

FIRST... the gesture of the hand— this should capture a unified flow of the rather complex structure.

NEXT... an organized arrangement of the moving parts. Note how this blocking-in method ensures that the joints will "hinge" properly.

FINISHED DRAWING ... observe how both the gesture and the structure have been retained.

Slip a sheet of white paper under this overlay for easy viewing. You can remove it for comparison with your Practice Project. You'll find these suggestions from an Instructor of the Famous Artists School most helpful.

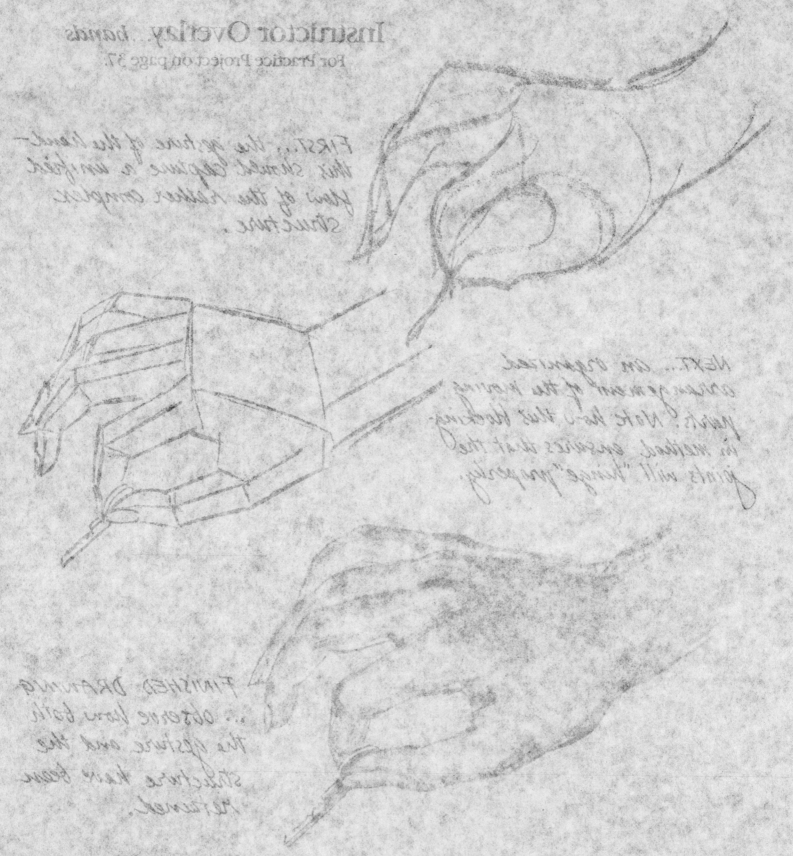

Instructor Overlay
...*simplifying the values.*
For Practice Project on pages 42 and 43.

For Practice Project on pages 42 and 43.

Establishing a well-designed BLACK PATTERN is the most important step. This small diagram is the key to a strong picture impact.

Here we have added two GRAY VALUES... light and dark

In this composition we have used THREE GRAY VALUES... giving us the basis of a painting much like Ben Stahl's portrait on page 47.

Slip a sheet of white paper under this overlay for easy viewing. You can also remove it and place it over your Practice Project for comparison and helpful suggestions from an Instructor of the Famous Artists School.

Instructor Overlay
...simplifying the values.
For Practice Project on pages 42 and 43.

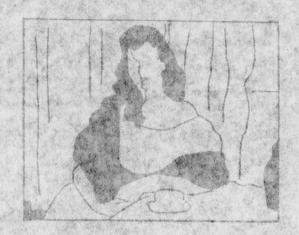

Establishing a well-designed black pattern is the most important step. This simple diagram is the key to a strong picture impact.

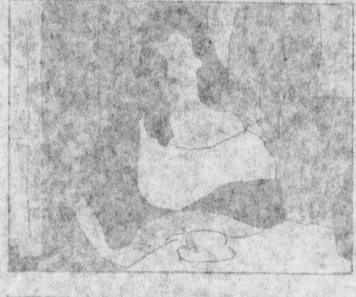

Here we have added two GRAY VALUES... light and dark.

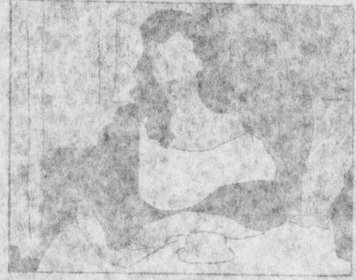

In this composition we have used THREE GRAY VALUES... giving us the basis of a painting much like John Stobart's portrait on page 42.

Slip a sheet of white paper under this overlay for easy viewing. You can also remove it and place it over your Practice Project for comparison and helpful suggestions from an Instructor of the Famous Artists School.

86

Instructor Overlay...*pencil portrait*
For Practice Project on pages 52 and 53.

Remember the BASIC HEAD beneath the hair –

The SHADOW PATTERN is not obvious, but it helps to emphasize it – Compare this sketch with the final picture.

See how the hair masses are organized with a light and dark pattern as shown above.

A secondary light catches the form of her cheek.

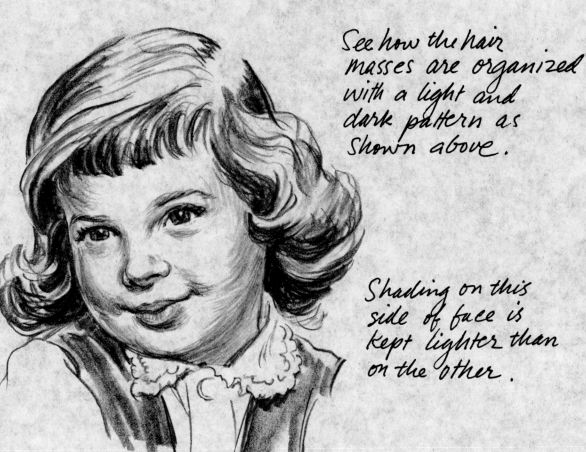

Shading on this side of face is kept lighter than on the other.

Slip a sheet of white paper under this overlay for easy viewing. You can remove it for comparison with your Practice Project. You'll find these suggestions from an Instructor of the Famous Artists School most helpful.

Remember, the BASIC HEAD beneath the hair.

The SHADOW PATTERN is not obvious, but it helps to emphasize it. Compare this sketch with the found picture.

See how the hair masses are organized with a light and dark pattern as shown above.

A secondary light catches the form of her cheek.

Shading on this side of face is kept lighter than on the other.

Slip a sheet of white paper under this overlay for easy viewing. You can remove it for comparison with your Practice Project. You'll find these suggestions from an Instructor of the Famous Artists School most helpful.

87

Outline Guide...*portrait painting*
For Practice Project on page 65.

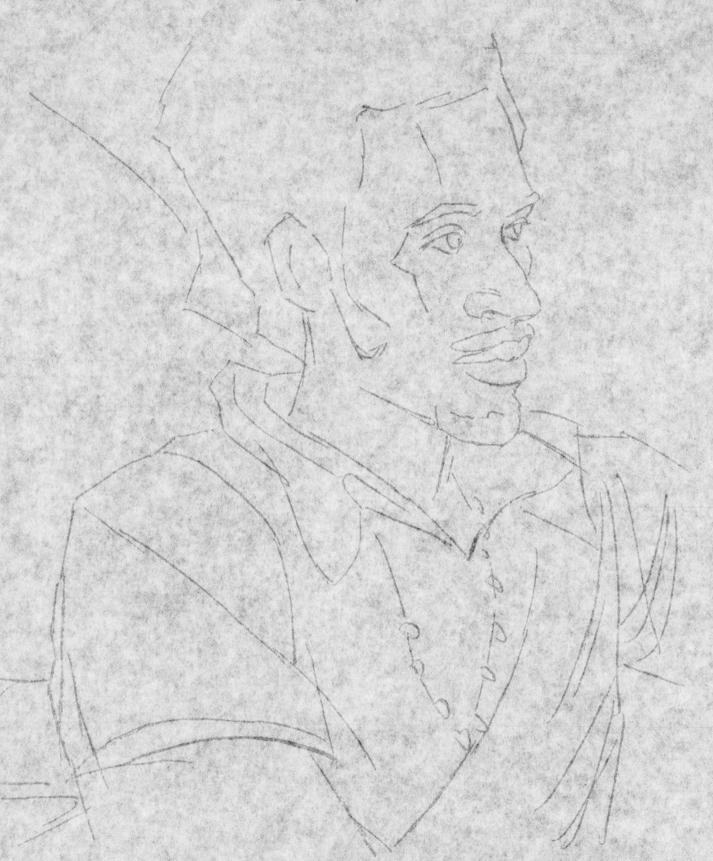

Instructor Overlay...*girl with black pony-tail*
For Practice Project on pages 68 and 69.

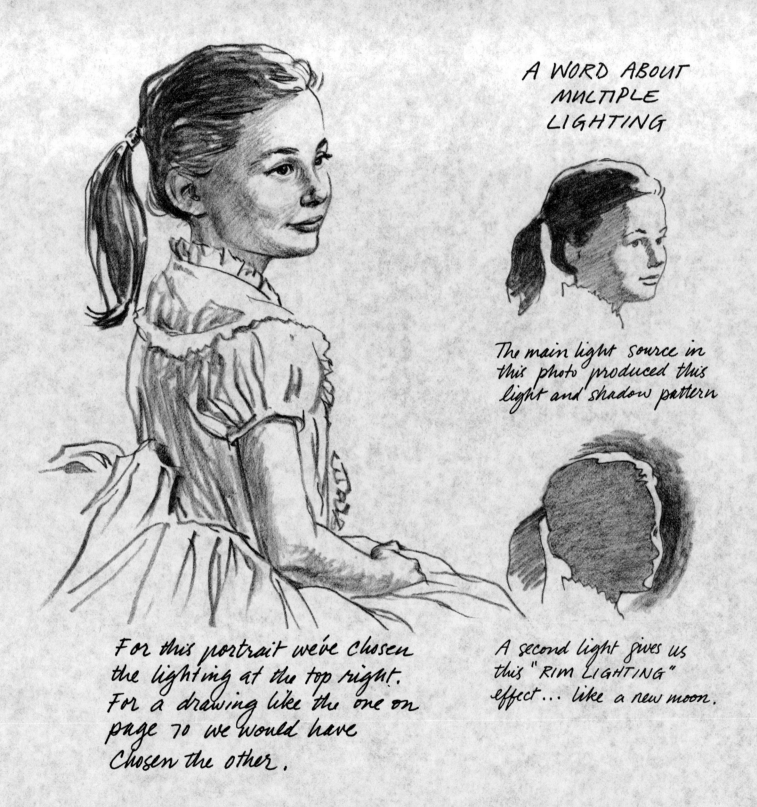

A WORD ABOUT MULTIPLE LIGHTING

The main light source in this photo produced this light and shadow pattern

For this portrait we've chosen the lighting at the top right. For a drawing like the one on page 70 we would have chosen the other.

A second light gives us this "RIM LIGHTING" effect... like a new moon.

Slip a sheet of white paper under this overlay for easy viewing. You can remove it for comparison with your Practice Project. You'll find these suggestions from an Instructor of the Famous Artists School most helpful.

A WORD ABOUT MULTIPLE LIGHTING

The main light source in this photo produced this light and shadow pattern

A second light gives us this "Rim lighting" effect . . . like a new moon.

For that you didn't were chosen the lighting of the top right. For a drawing like the one on page 70 we would have chosen the other.

Slip a sheet of white paper under this overlay for easy viewing. You can remove it for comparison with your Practice Project. You'll find these suggestions from an Instructor of the Famous Artists School most helpful.

Tracing Paper. These sheets will give you a chance to try out this useful and popular type of paper. Similar paper is readily available at stores selling art supplies.

TEAR OUT PAGE ALONG THE PERFORATION

Tracing Paper. These sheets will give you a chance to try out this useful and popular type of paper. Similar paper is readily available at stores selling art supplies.

Tracing Paper. These sheets will give you a chance to try out this useful and popular type of paper. Similar paper is readily available at stores selling art supplies.

Tracing Paper. These sheets will give you a chance to try out this useful and popular type of paper. Similar paper is readily available at stores selling art supplies.

Tracing Paper. These sheets will give you a chance to try out this useful and popular type of paper. Similar paper is readily available at stores selling art supplies.

Tracing Paper. These sheets will give you a chance to try out this useful and popular type of paper. Similar paper is readily available at stores selling art supplies.

Tracing Paper. These sheets will give you a chance to try out this useful and popular type of paper. Similar paper is readily available at stores selling art supplies.

TEAR OUT PAGE ALONG THE PERFORATION

Tracing Paper. These sheets will give you a chance to try out this useful and popular type of paper. Similar paper is readily available at stores selling art supplies.

Tracing Paper. These sheets will give you a chance to try out this useful and popular type of paper. Similar paper is readily available at stores selling art supplies.

TEAR OUT PAGE ALONG THE PERFORATION

Famous Artists School
invites you to enjoy this valuable FREE Art Lesson

Just complete this FREE Art Lesson using your own natural talents and what you have learned from this step-by-step method book. The Lesson covers several areas of artistic development. Then fill in the information on the reverse side, fold as indicated and mail to Famous Artists School. A member of our professional Instruction Staff will personally evaluate your Special Art Lesson and return it to you with helpful suggestions. You will also receive information describing the complete Famous Artists School courses which will open up a world of personal satisfaction and creative achievement for you. No obligation—this personal evaluation and information are yours absolutely free. Don't miss this important opportunity—mail this valuable Art Lesson today.

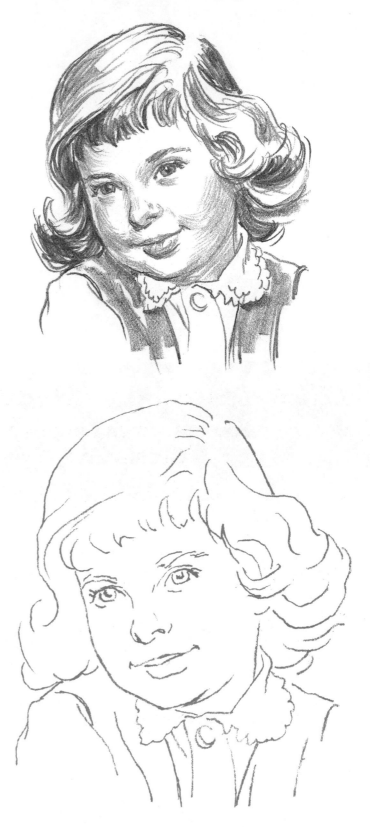

Using an ordinary soft pencil, complete this outline drawing of a child's portrait by drawing in the shading to give it solid form. Notice in the drawing above how the strong, simple lighting creates a contrasting pattern, separating light and shaded areas.

Picture composition…how shapes fit together

- All pictures are composed of shapes. Objects in a picture are called positive shapes. The remaining areas are negative shapes. Indicate the total number of separate shapes, both positive and negative, that you see in the design at right.

 In this example there are two shapes

one two three four five six

Observation…part natural and part learned

- On a bright, sunny day, the color of green leaves on a tree looks
 a) yellow-green in sunlight and blue-green in the shadows
 b) blue-green in sunlight and yellow-green in the shadows
 c) the same in sunlight and shadow

- Which triangle appears closest to you?

- Half close your eyes as you look at these four panels. While squinting, which one appears to be the darkest?

A B C D

Lighting…shadow pattern reveals form

- Diagram A shows the way the shadows would look if there was one light source as shown. Using a pencil or pen, shade in how the shadows would fall on Box B with the same light.

DETACH HERE